IMAGES
of America

DETROIT'S LOST AMUSEMENT PARKS

IMAGES
of America

DETROIT'S LOST
AMUSEMENT PARKS

Joseph McCauley

ARCADIA
PUBLISHING

Published by Arcadia Publishing
Charleston, South Carolina

Printed in the United States of America

Library of Congress Control Number: 2023931692

For all general information, please contact Arcadia Publishing:
Telephone 843-853-2070
Fax 843-853-0044
E-mail sales@arcadiapublishing.com
For customer service and orders:
Toll-Free 1-888-313-2665

Visit us on the Internet at www.arcadiapublishing.com

This book is dedicated to my lovely wife, Grace McCauley, and my recently departed brothers Michael and Charles McCauley.

CONTENTS

ACKNOWLEDGMENTS

This book was created with the help and generosity of many people I have met or corresponded with over many years. Their photographs, stories, and friendship have made this *Detroit's Lost Amusement Parks* history possible.

Having grown up in the area, I have a special bond with many contributors and hope I have made a decent representation of our childhood and early adulthood in the 1950s, 1960s, 1970s, and beyond.

Special thanks to all the people who shared photographs within the book.

I couldn't have completed this book without the assistance of: Elizabeth Clemons, Wayne State-Reuther Library Virtual Motor City; Carla Reczek; the Detroit Public Library Burton Collection; Katrina Kochneva, Zuma Press Licensing, for the *Detroit Free Press* and *Detroit News*; Jeremy Dimick, Detroit Historical Society; *Detroit Free Press*; Betty Lang, Novi Public Library; Meg Reiner, Southeastern Ontario Digital Collection; Sue Pixley, East Detroit Historical Society; Janine Rebbie, Philadelphia Toboggan Company; Victoria Duncan, Indiana State Library; Britney Fields, Mount Clemens Public Library; John Martin Strauss family; Roberto Huston; Jim Feliciano's Motor City Radio Flashbacks; Rosemary Orlando, St. Clair Shores Historical Society; Dan Rubenstein, Yestergoods; Aaron Schillinger, Sarah E. Ray Project; Christopher Lock, *Michigan State Fair Memories: 1959–2009*; Stephen Silverman, *The Amusement Park*; Robert Christenson, *The Halfway–East Detroit Story*; Andy Walker; John Fitzgerald; Andrew Piper; David and Judy Shedlock; Refried Jeans Postcards; Historical Images; Lori Marshick; Newspapers.com; Aubrey Dickens, Clarke Historical Library; Sue Williams and Gina Gregory, Greater West Bloomfield Historical Society; eBay; and Grace Colette McCauley.

Unless attributed otherwise, all images appear courtesy of the author.

INTRODUCTION

Amusement parks were popping up in cities like New York, Boston, and Chicago in the late 1890s. Detroit was the 13th largest city in the United States with 285,106 people living in its boundaries. After visiting parks in Europe and the United States, widely known insurance man Arthur C. Gaulker decided Detroit needed its own top-ranked amusement park.

Electric Park, also known as Luna Park, Riverview Park, and Granada Park in later years, opened in 1905 and was located at the foot of the Belle Isle Bridge by Jefferson Avenue just a few miles north of downtown Detroit. Three streetcar lines ended there at the entrance, where a windmill stood with a sign reading "The Boardwalk: Just for Fun."

Just east of Belle Isle, Wolff's Park was opened in 1905 by Morris Wolff after he bought Beller's Garden saloon. His amusement park included a Ferris wheel, a 3,000-foot roller coaster, and the "largest roller skating rink in the West," plus a dancing pavilion and more.

Wolff's park went into receivership in 1907 and became Riverview Park that fall. In 1915, the largest roller coaster in the world opened. It was the mile-long Trip Thru the Clouds.

West of Riverview Amusement Park was the Kling Brewery, which closed after Prohibition began. The Klings razed the brewery and built Luna Park. After a few years, it was renamed Granada Park when it opened on June 28, 1924.

During this period between 1920 and 1940, Detroit became the fourth largest city in the country. Immigrants and a steady flow of workers from down south often used their recreation dollars on amusement parks.

Eastwood Park opened in 1926, and Jefferson Beach Park in 1927, Edgewater Park in 1927, Walled Lake in 1929 soon followed. The Michigan State Fair also had an amusement park to go along with the agricultural exhibits brought in from around the state.

Bob-Lo Island Amusement Park opened in 1949. The island was an hour's boat ride south from downtown Detroit. The park was a half-mile wide and three miles long. It was located at the mouth of the Detroit River on the Canadian side.

Friday and Saturday night two-hour moonlight cruises on the SS *Ste. Claire* and SS *Columbia* were very popular. The two steamships were listed on the National Historic Registry and swept the romantically inclined from 11:00 p.m. to 1:00 a.m. along the Detroit River.

Music, barkers, yells, and sometimes screams of delight and fear mixed with pungent smells of cigars, cigarettes, popcorn, and hot dogs enveloped the amusement park crowds.

Top-notch musical performers from big-band acts like Tommy Dorsey, Lawrence Welk, Glenn Miller, and Cab Calloway, as well as rock performers like David Cassidy and ZZ Top and Motown stars like The Supremes, all took their turns entertaining Detroit amusement park attendees.

Edgewater Park had a good run from 1927 until 1981, when it was razed after a fire and a few years of neglect. Its old site is now home to Greater Grace Temple Church at 7 Mile and Berg Roads in Detroit proper.

Bob-Lo Island Amusement Park lasted from 1949 until 1993, when a new owner, Michael Moodenbaugh, had a near-fatal accident while planning a makeover of the park. His business partner sold his interest in the park, and a housing project was built while rides and other park equipment were sold off.

The old parks are gone ,but baby boomers still fondly remember Edgewater and Bob-Lo Amusement Parks. Countless school, civic, and church groups made yearly excursions to both parks. Detroit's amusement park memories still live on with the folks who were able to enjoy wooden roller coasters and Detroit River boat rides.

One

DETROIT'S ORIGINAL AMUSEMENT PARKS

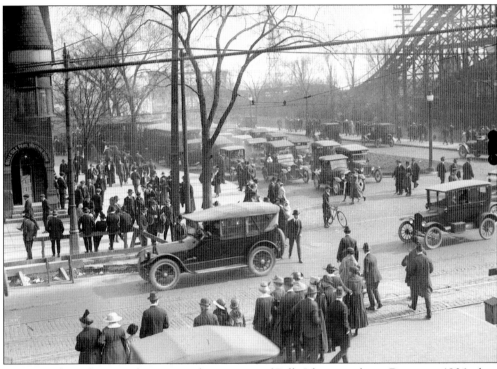

A spectacular sight greeted visitors to the entrance of Belle Isle in northeast Detroit in 1906 when two amusement parks—Electric Park and Wolff's Amusement Park—were created on either side of the bridge on Jefferson Avenue. Arthur C. Gaulker, a wealthy real estate and fire insurance agent who had scouted out a variety of amusement parks in Europe and America for several years, set out to create the biggest amusement park in the world. Electric Park, lit up with 75,000 incandescent bulbs at night, was six times the size of the resort to the west of the Belle Isle Bridge that it replaced. The previous year, 300,000 people visited the resort. The park became seven acres large once a mammoth pier was completed. Gaulker spent $250,000 in real estate and $30,000 for a new roller coaster plus $100,000 in rides like the Electric Circle Swing, the Double Swirl, and the House that Jack Built. Just to the east of the Belle Isle Bridge, entrepreneur Morris Wolff bought Beller's Garden saloon in 1905 and built his park, which covered eight acres or 315,500 square feet. Wolff's Park had a Ferris wheel, a 3,000-foot-long roller coaster, a dancing pavilion, the largest roller skating rink in the West, bathhouses, an airship, and more. The pavilion had a seating capacity of 1,600 people and included a sun porch with a view of Belle Isle and the Detroit River. The Tacoma Canoe Club had its headquarters on the water under the pavilion.

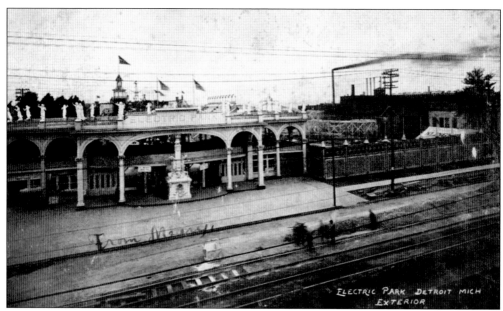

Electric Park was originally a trolley park with three streetcar lines ending there at Jefferson Avenue and East Grand Boulevard. The entrance was enlarged and beautifully decorated. Eight statues (four men and four women) representing electricity were situated on the roof. The women statues supported a large electric globe that was topped by an American eagle. The interurban streetcar tracks of the Shore Line are in the foreground. (Courtesy of Detroit Historical Society.)

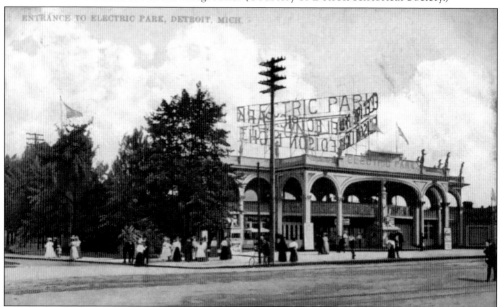

Admission to Electric Park was 10¢, and parkgoers could enjoy fortune tellers, fun houses, slides, a railway, musical concerts, vaudeville shows, various animals, acrobats, jugglers, and a roof garden, according to the *Detroit Free Press* in 1906. Park founder Arthur Gaulker knew there were 400,000 residents in Detroit plus one million potential customers in a 25-mile radius of the city and figured he could make a tidy profit with his investors. (Courtesy of the Burton Historical Collection, Detroit Public Library.)

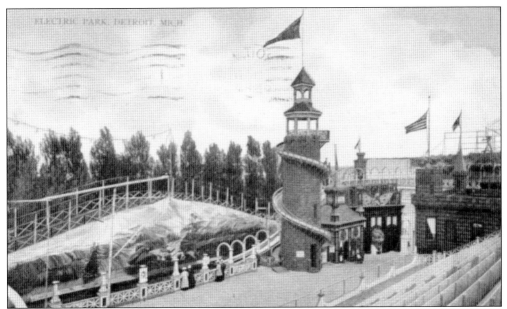

One of the most popular rides at Electric Park was the Down and Out tower. This round 85-foot-high tower had a spiral path or gutter that wound around the outside. Riders walked up a spiral staircase inside the tower then sat down on a polished maple slide and began descending feet first to the bottom. Going round and round while picking up speed, thrill seekers finally reached the end with a gradual finish. The Down and Out tower was free to park visitors.

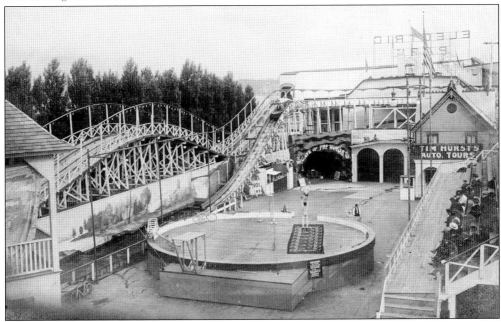

The Tim Hurst Auto Tours site from the previous small park became the administration building, while the Cave of the Winds was replaced by the House of Nemo during the expansion in 1906. Nearby is a circular stage with props where acrobats and other aerial acts performed. To the left is part of the roller coaster. On the right are the bleachers. (Courtesy of the Burton Historical Collection, Detroit Public Library.)

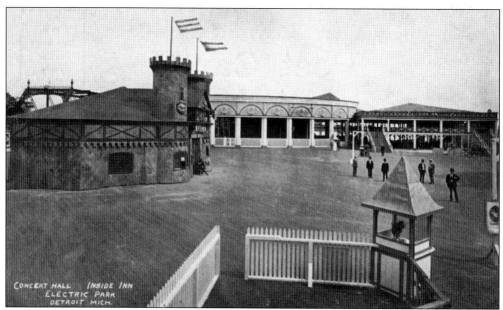

On the wall in the director's office in the Electric Park concert hall was the motto "Only the Best." Concerts held by Giuseppe Creatore and John Philip Sousa were among those that proved the point. Creatore's band cost $5,000 a night and caused Electric Park to charge a fee for admission. Another popular performer was American prima donna soprano Nellie Turnbull, who toured with Rosati's Royal Italian Band. The 48th Highlanders were another crowd favorite. (Courtesy of the Burton Historical Collection, Detroit Public Library.)

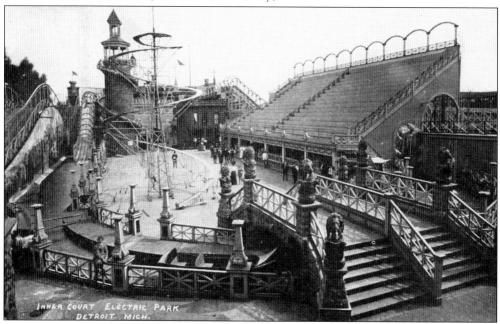

This is a photograph of a grandstand facing a spiral slide in Electric Park. The bridge is decorated with lion heads and crosses over the water ride. A man sits on a fence in the foreground with the Down and Out tower in the background. The Electric Park's largest crowd of 29,000 visited during the 1906 Fourth of July. (Courtesy of the Burton Historical Collection, Detroit Public Library.)

The Electric Park Shoot the Rapids ride featured a rapid descent and splashdown into a body of water, which happened more than once (the largest drop being just before the end). It provided people with an entertaining way to get wet and cool off on a hot summer day, with certain seating sections usually being splashed with more water for an exhilarating and wet ride. (Courtesy of Virtual Motor City Collection, Wayne State University.)

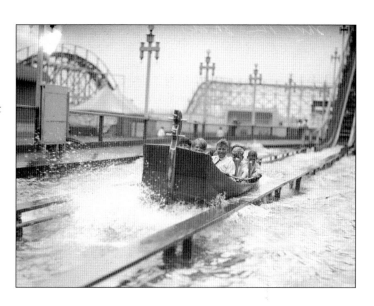

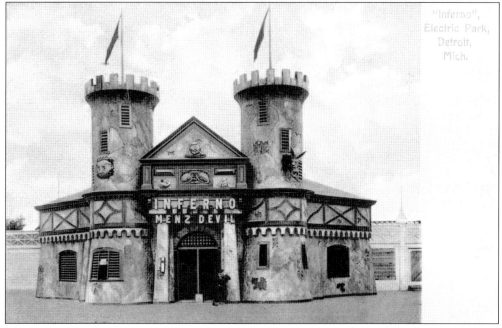

The Inferno was a maze in the shape of a castle with a devil statue by local German stone cutter Herman Menz inside. Initially, Menz displayed the statue in front of his Detroit house, but after neighbors threatened him, the devil was sold to Electric Park owner Arthur Gaulker for $40. Originally thought to be a good investment, the devil was cast out of the park when people considered it bad luck or a hoodoo. It was carted away in a wagon and dumped over an alley fence face down. (Courtesy of Detroit Historical Society.)

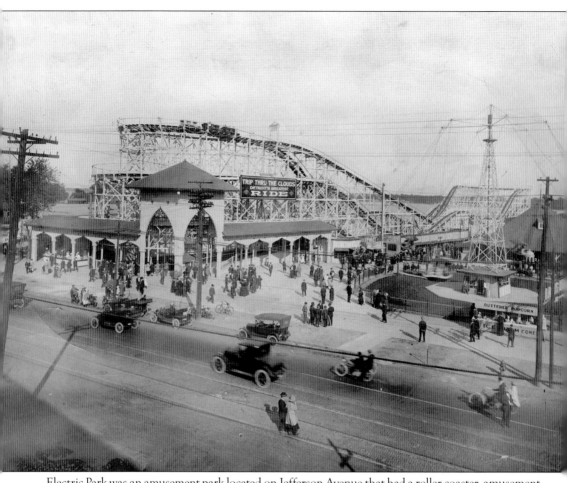

Electric Park was an amusement park located on Jefferson Avenue that had a roller coaster, amusement rides, a refreshment stand, and pedestrians on the grounds. Model T cars and motorcycles are in the foreground. The sign on the roller coaster reads, "Trip thru the clouds, Detroit's greatest ride." The concession stand on the right sold buttered popcorn and ice cream. Initially, owner Gaulker and his investors sank about $1 million into the park. (Courtesy of Burton Historical Collection, Detroit Public Library.)

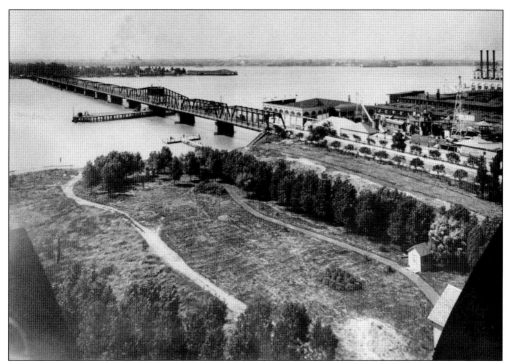

This photograph overlooks the Belle Isle Bridge from an elevated position to the northeast above the park on the east side of the approach to the bridge. Electric Park is visible across the approach. A pier extends from one of the pylons on the bridge. The Pavilion Ferry Dock on the southwest edge of Belle Isle is in the background. The bridge was completely destroyed by fire in 1915. (Courtesy of Detroit Historical Society.)

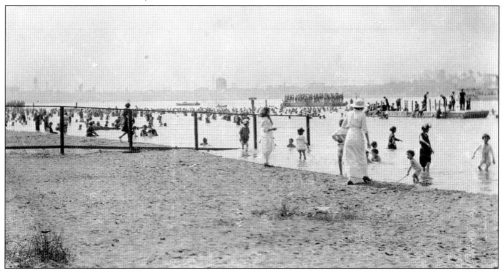

Beachgoers frolic along the beach and in the water off Belle Isle. Signs indicating the river's depth are painted on the side of the small break walls off the shore. A fence extending to the water divides the beach. Canoes and an excursion steamer are visible in the river. The roller coaster in Electric Park is visible along the opposing shore in the background. Note the long women's dresses. (Courtesy of Detroit Historical Society.)

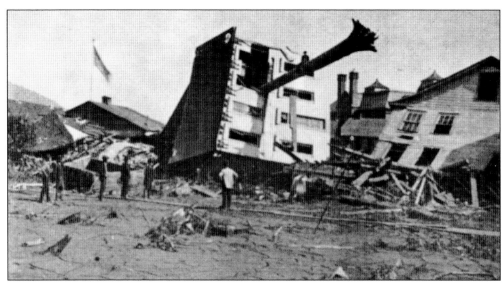

A scale model of the horrendous flood of 1889 in Johnstown, Pennsylvania, that killed thousands was a favorite attraction at Electric Park. Other entertainment featured aerial and high-wire acts. The Big Dipper, the Bobs, and the Dare Devil were roller coasters for those who were not faint of heart. According to owner Arthur Gaulker, "Detroit's new Electric Park will be one of the largest in the world. Rome with its seven hills will be a poor second to the roller coaster which will be installed on the western side of the park. Here will be found 14 hills and any amount of hilarious fun may be derived within the enclosure."

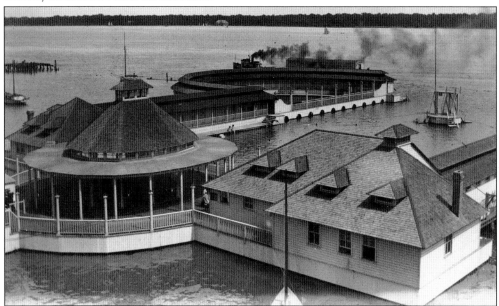

A circular pavilion with a conical roof stands on a pier between two buildings with cross-hipped roofs and gables. In the background to the east, a semicircular pavilion extends farther into the Detroit River. Several figures in bathing suits sit or dive from the walkway in the center of the photograph. A tugboat pulls a covered Pittman and Dean Company barge past the pavilion. The Detroit Yacht Club can be seen on the shore of Belle Isle in the background. (Courtesy of Detroit Historical Society.)

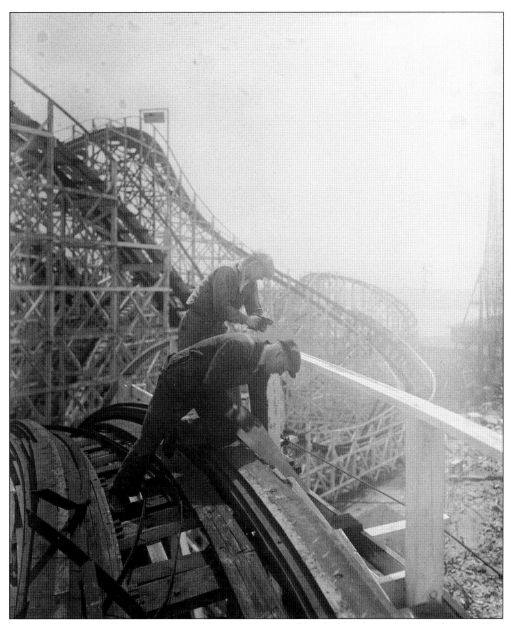

In 1909, after dwindling revenue and a competing Wolff's Park next door, owner Arthur Gaulker closed his park with the hope of reorganizing his business. "Everything was against us this year," declared Gaulker. "Then came the legal action, by which we lost a big section of the west side of the park." Some workers (like carpenters) suffered payless paydays during the bankruptcy. (Courtesy of Virtual Motor City Collection, Wayne State University.)

Meanwhile next door, businessman Morris Wolff bought the old Beller's Garden saloon (depicted in the center) just east of the Belle Isle Bridge by the Detroit River in 1905. Wolff's Park had a Japanese café where 60 people could be served at one time. There was also a Japanese garden, House of Mirth, a miniature railroad, the Colonial Theater, the Sleepville Hotel, and an electric push-button novelty where everyone got a fine souvenir.

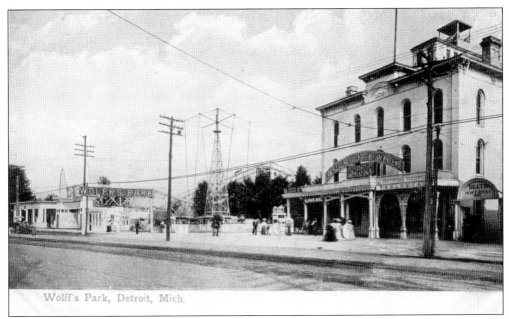

Wolff's Park, Detroit, Mich.

Wolff's Park remodeled buildings on the site, and 16 brand new attractions were added, like a circle swing, Ferris wheel, up-to-date bathrooms, an airship, and the longest roller coaster in the world. There was also a gigantic dancing pavilion (65 by 55 feet) that seated 1,600 people. Bathers were provided with new suits, and the women's and children's apartments were all newly painted and remodeled. Two expert swimming teachers were engaged by management. J. Humberger, with seven years of experience, became in charge of the swimming department.

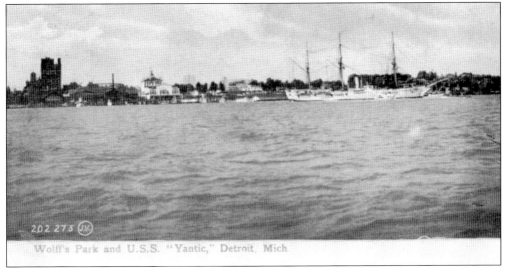

Wolff's Park and U.S.S. "Yantic," Detroit, Mich.

The USS *Yantic* is shown here docked by Wolff's Park. It was a gunboat that saw action in the Civil War. In 1898, the *Yantic* was loaned to the Naval Militia of the State of Michigan as a training ship on the Great Lakes until 1917. The *Yantic* suddenly sank alongside the dock at the foot of Townsend Avenue in Detroit on October 22, 1929. Further investigation revealed that the sinking had been caused by structural weakening because of natural deterioration. The hull is still buried in a filled-in boat slip in Gabriel Richard Park, where Wolff's Park used to be. The anchor sits in front of the Detroit Naval Armory at 7600 East Jefferson Street.

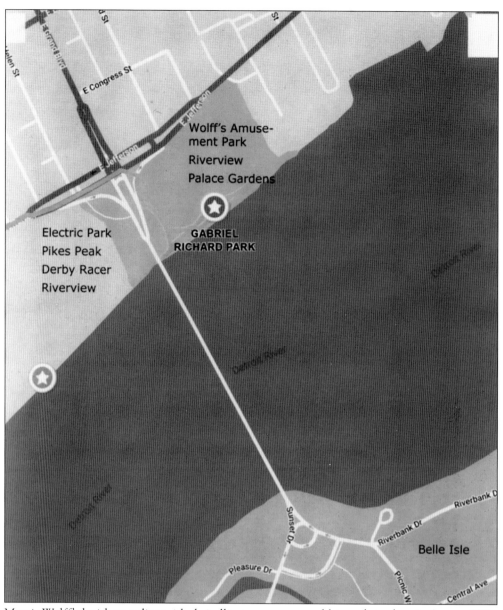

Morris Wolff's lavish spending with dwindling revenue caused his park to close in August 1907. By September, Wolff's Park, or "Riverview Park" as it has been called since the Wolff family ceased to be in charge, underwent a change in management, with Charles Rosenzweig becoming general manager. Wolff ceased to be a factor in the management of the park for the time being. This map shows the location of different parks over the years at the base of the Belle Isle Bridge. (Courtesy of Google maps.)

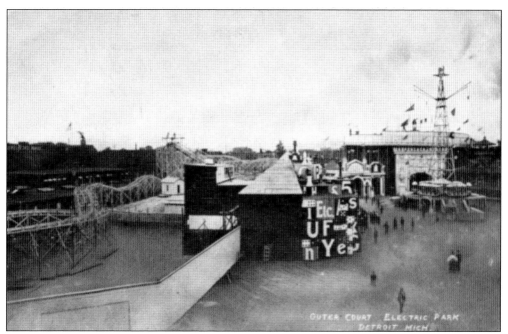

Electric Park owner Arthur Gaulker tried to reverse sinking revenues by dropping the 10¢ admission at the start of the 1909 season. New coasters, new chutes, new halls of mirth, and new concessions were added to the House that Jack Built attraction. Men and women are shown standing in the outer court of Electric Park. A roller coaster is on the left, with an amusement ride decorated with flags on the right. The House that Jack Built is decorated with images of letters and dice. (Courtesy of Burton Historical Collection, Detroit Public Library.)

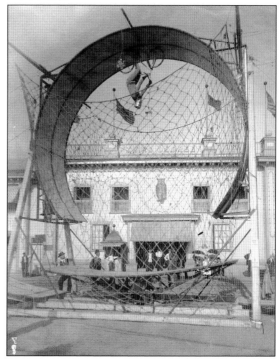

Another big attraction that Gaulker brought to the park was Oscar Babcock, who was billed as "the World's Greatest Cyclist." Babcock was the early-1900s Evil Knievel. His act, according to the *Detroit Free Press*, differed from all others in the one particular that he depended entirely upon muscle, nerve, and clear-headedness to accomplish his death-defying trip through the loop and the trap over the gap. He had to steer and hold steady his own machine, and to waver the slightest would mean death to him. He started at the top of an incline 50 feet high and dashed down through the death trap, around the loop, out of the death trap, and over a 40-foot gap. (Courtesy of Victoria Duncan, Indiana State Library.)

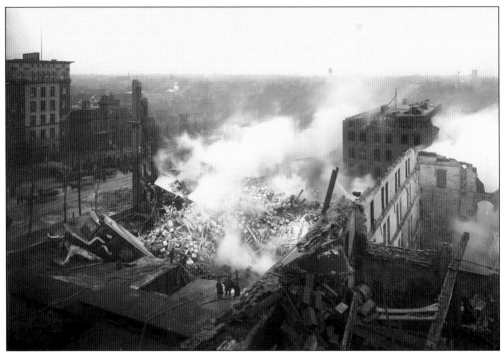

Despite adding more and newer attractions, Gaulker's park struggled to make a profit. Electric Park closed on August 16, 1909, and it was ordered sold. Half of the park was demolished in 1911, and a portion was bought by Detroit Stove Works next door. Additionally, a fire destroyed several rides on the other half. The novelty of the park had seemingly worn off. (Courtesy of Detroit Historical Society.)

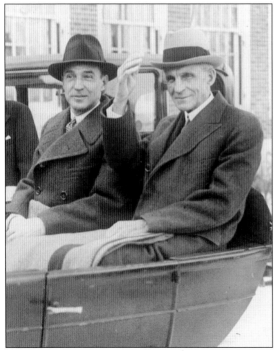

Gaulker sold his family's 21 acres of Gaulker's Point property on Lake St. Clair to Henry Ford and used the money to save what was left of Electric Park from foreclosure. He began erecting a new two-mile roller coaster but died in 1912 before it could be finished. The park's site and coaster opened as Pike's Peak, which later became the Derby Racer, and finally was absorbed by Riverview Park. Meanwhile, Henry Ford (right) had his son Edsel Ford (left) build his house on Gaulker's Point in Grosse Pointe Shores. Famed architect Albert Kahn built the mansion. The house is open to the public now and is on the National Register of Historic Sites. (Courtesy of Virtual Motor City Collection, Wayne State University.)

Two

REINCARNATED AMUSEMENT PARKS

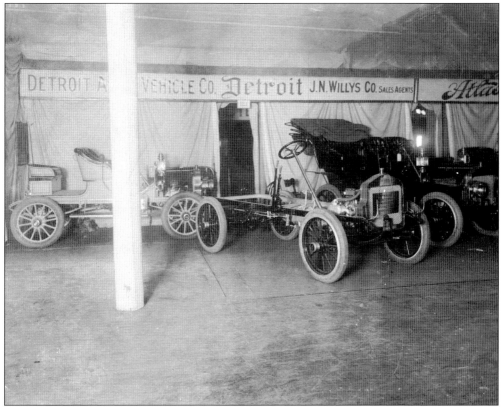

After Wolff's Amusement Park and Electric Park went bankrupt, there were several that took their place on each side of the entrance to Belle Isle. Riverview Park was the first that replaced Wolff's Park when it hosted Detroit Auto Show in 1907. The first Detroit Auto Show was held at Riverview Park and featured 33 vehicles offered by 17 exhibitors. A group of 16 auto dealers sponsoring that original show eventually became the Detroit Auto Dealers Association (DADA). Gasoline cars, electric cars, and steam-powered cars were displayed. Kane Starting Devices (a Detroit company) also introduced its product to replace the cranking systems that most vehicles used at the time. (Courtesy of Burton Historical Collection, Detroit Public Library.)

With the success of the Detroit Auto Show still fresh, manager Harry Nederlander announced that Riverview Park would be kept in operation through the winter and that arrangements had already been made for the installation of a heating system. Refreshments of all kinds would be bought, and the management would rebate the extra nickel that was charged on each bottle of beer when sold under the Wolff regime. Nederlander said that as soon as he could install a kitchen, he would serve dinners to parties. Game, in season, would be his specialty. The park would be "catering strictly to a solid respectable class of people and the vaudeville performances containing the best local talent, are purely high class and far removed from the faintest hint of suggestion," according to Nederlander. (Courtesy of Virtual Motor City Collection, Wayne State University.)

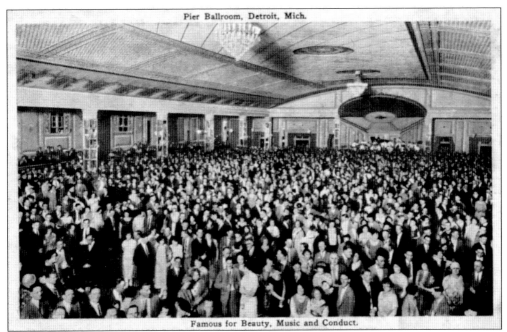

The Pier Ballroom was famous for its beauty, music, and conduct. Among its great features were the pier pavilion and theater and Pier Inn. The ballroom was located at the Detroit Riverfront, within hailing distance of passing steamboats, with the wonderful theater and pavilion and accommodated more than 5,000 people. (Courtesy of Burton Collection, Detroit Public Library.)

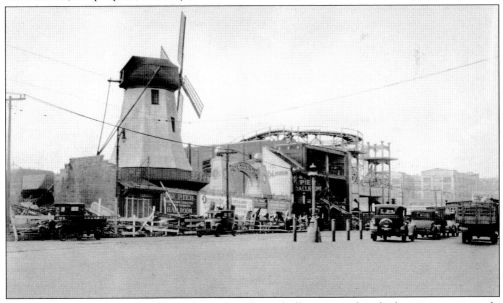

Palace Gardens (the former Pier Ballroom), a dance hall associated with the amusement park, was destroyed by fire in May 1911 at a loss of $130,000. Other buildings burned down were the Riverview Hotel, the adjoining pavilion, and the vaudeville theater. The fire was witnessed by 25,000 people. Two yachts were destroyed, and the Lamet and Steers Engine Company sustained $10,000 in damages. The coliseum and pier, the largest concession on the riverfront, burned down in February 1921. (Courtesy of Burton Historical Collection, Detroit Public Library.)

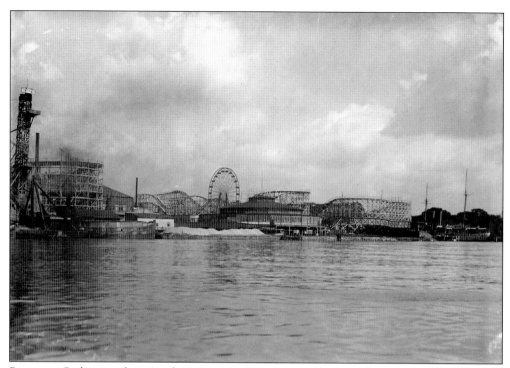

Riverview Park opened on April 30, 1911, with many new features like the new Riverview Pier, which annexed the Detroit River to Riverview Park. The pier, 250 feet long and 32 feet wide, was lighted by flaming arc lamps and equipped with park benches for the ladies and babies. In the casino, there was vaudeville every afternoon and evening. Admission to the casino was free, and the music was provided by the Professor Harris Orchestra. (Courtesy of Virtual Motor City Collection, Wayne State University.)

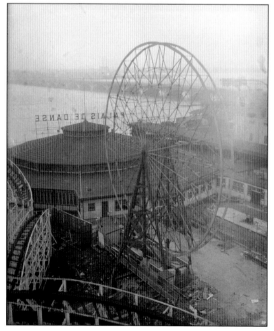

The Palais de Danse, also known as the Queen of the Ballrooms, was built by Charles Rosenzweig in 1912. The ballroom extended out over the Detroit River and was a favorite of many who came to dance to the music of distinguished bands like Floyd Hickman's Orchestra (a local jazz band), John Philip Sousa, Guiseppe Creatore's Band, and the Rosati Royal Italian Band. Over 7,000 people could strut their stuff in the ballroom. (Courtesy of Virtual Motor City Collection, Wayne State University.)

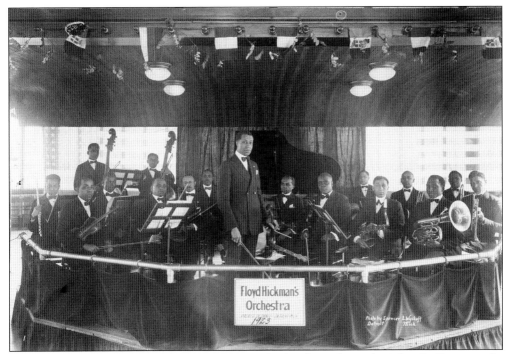

Floyd Hickman's Orchestra was one of many popular bands to play at the Palais De Danse in the mid-1920s. Musicians from the band pose onstage with musical instruments. The sign on the railing reads, "Floyd Hickman's Orchestra, Palais de Danse, Detroit, Mich." Printed on the front is, "Photo by Spencer & Wyckoff, Detroit, Mich." Handwritten on the front is, "Clyde Hayes, bass. Litt. Smith, bass. Floyd Hickman, leader. Geo. Massey, drums. Ben Mitchel, baritone. John Tobias, trombone. Norvel Morton, flute. Ray Scott, violin. Fred Kewley, claironet [sic]. Harry Jordan, violin. Bill Henson, bassason [sic]. Wen Talbert, piano. Orla Harris, violin. A.L. Robinson, violin. Joe Johnson, sax. Oscar Smith, trumpet. Joe Buckner, trumpet. 1923." (Courtesy of Burton Historical Collection, Detroit Public Library.)

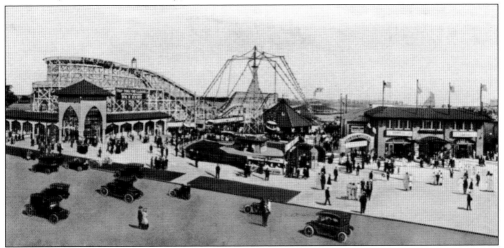

The Trip Thru the Clouds (left), built by Josiah Pierce and Sons of New Orleans, Louisiana, was the biggest ride in Michigan and one of the largest in the world. A fascinating feature of the ride is that half of it was over the surface of the Detroit River. (Courtesy of Burton Collection, Detroit Public Library.)

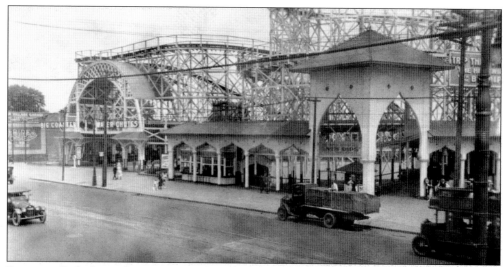

Riverview Park changed its name to Palace Gardens in 1914, and the new park was lit by Peerless Tungsten lamps furnished by the Victor Electric Supply Company. This photograph of the entrance was taken on the west corner of Jefferson Avenue and Sheridan Street. A ticket booth, a concessions stand, and part of the roller coaster Trip Thru the Clouds are depicted. A double-decker bus, a truck, and a car are on Jefferson Avenue in the foreground. (Courtesy of Detroit Historical Collection.)

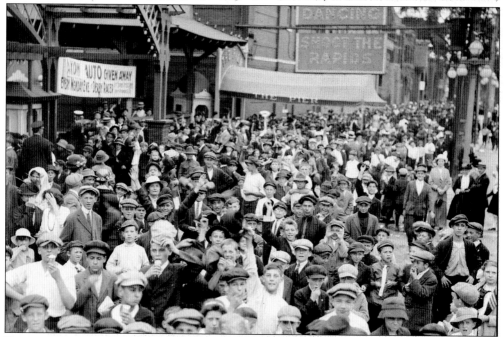

Every year, a variety of social and church groups and schoolchildren would visit the Detroit amusement parks. This group of newsboys is enjoying ice cream cones. Other entertainment included going to the largest and finest roller skating rink in Michigan at Jefferson Avenue and Field Street. Palace Gardens boasted new Richardson nickel-plated skates and a perfect floor with 20,000 square feet. The giant circle swing, along with the drop-the-dip coaster, joined the $25,000 reproduction of the Dayton Flood, which was declared to be better than the Johnstown Flood exhibit that was a feature of the World's Fair at Buffalo. (Courtesy of Virtual Motor City Collection, Wayne State University.)

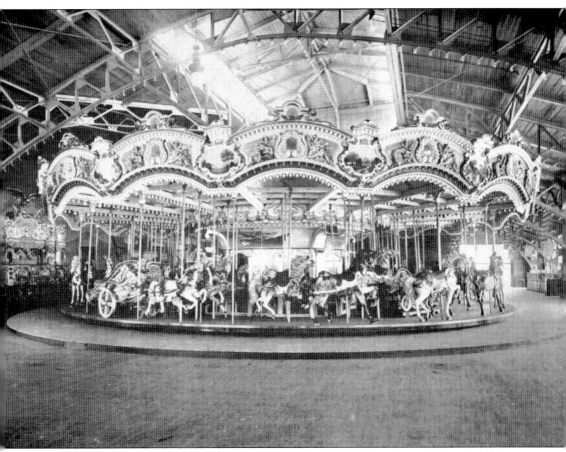

Prince Charming Regal Carrousel was constructed in 1918 for the Detroit Palace Gardens Park. The carousel was built by the Philadelphia Toboggan Company (PTC), which had named the attraction Miss Liberty and used a red, white, and blue color scheme. When the Detroit Palace Gardens Park went bankrupt, the carousel was moved to Philadelphia in 1928. In 1967, the carousel was extensively restored by the Disney Company for its new Florida theme park. (Courtesy of Janine Rebbie, Philadelphia Toboggan Company.)

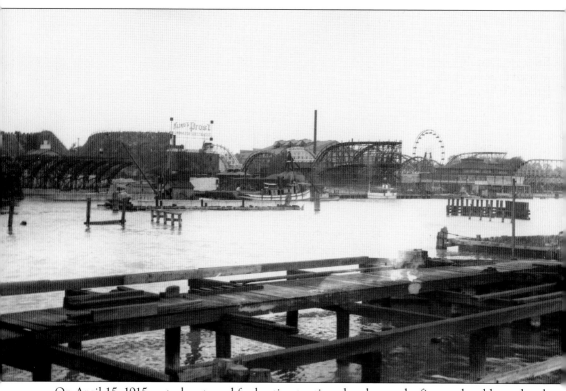

On April 15, 1915, a steel cart used for heating tar tipped and started a fire on the old wood-and-steel span that was the Belle Isle Bridge. The creosote blocks that paved the bridge made ready fuel to feed the blaze. This photograph shows Palace Gardens Amusement Park from the docks on Belle Isle to the southwest. The second Belle Isle Bridge is under construction across the river. (Courtesy of Detroit Historical Society.)

On Tuesday, November 27, 1906, Harry Houdini leaped manacled from the Belle Isle Bridge in Detroit, freeing himself from two pairs of handcuffs beneath the cold waters. A temporary bridge opened a year after the fire, in July 1916, just west of the old bridge. This structure remained in service until November 1, 1923, when the permanent, current bridge opened. Today, that span is officially the Douglas MacArthur Bridge, but most people just call it the "Belle Isle Bridge."

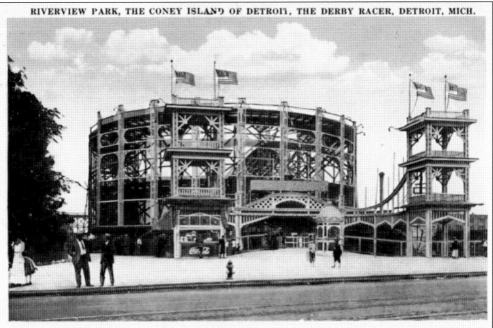

RIVERVIEW PARK, THE CONEY ISLAND OF DETROIT, THE DERBY RACER, DETROIT, MICH.

This postcard shows the street view of the Derby Racer thrill ride at Riverview Park in the early 1920s. The first Derby Racer coaster, at Revere Beach, Massachusetts, was built in 1911 by Fred Pearce for a cost of $140,000. The twin tracks of the Derby Racer were laid out in a figure-eight design. Many years later, Pearce claimed that when the coaster was constructed in 1911, the Derby Racer was the second largest roller coaster ever built. (Courtesy of Detroit Historical Society.)

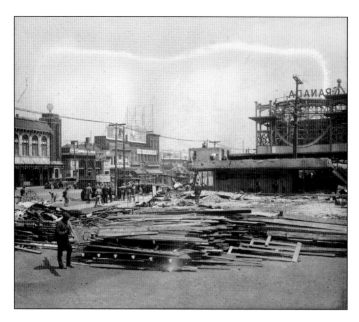

On November 1, 1921, about 200,000 feet of lumber and other building materials contained in the Derby Racer were up for bid by the Department of Buildings commissioner Frank Burton. All bids had to be accompanied by a certified check for five percent of the amount of the bid. All materials must be removed from the grounds located at the southwest corner of Jefferson Avenue and the Belle Isle Bridge approach. (Courtesy of Virtual Motor City Collection, Wayne State University.)

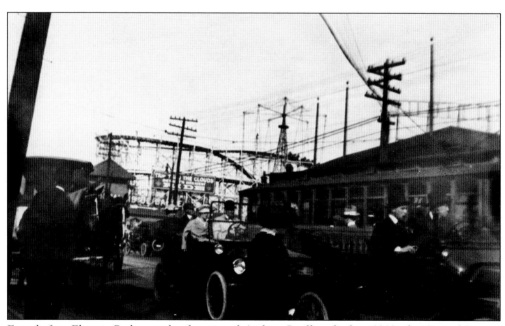

Even before Electric Park went bankrupt and Arthur Gaulker died in 1912, the City of Detroit sought to acquire the property on both sides of the Belle Isle Bridge approach between Jefferson Avenue and the river. People who lived in the area were vocal in their condemnation of the parks as a public nuisance and disturber of public peace. Police did their best in prohibiting parking on the streets near the amusement parks. Westbound traffic on East Jefferson Avenue is shown, with the Palace Gardens in the background. Automobiles, a horse-drawn carriage, and a streetcar are in the foreground. (Courtesy of Detroit Historical Society.)

The *Success* was built in 1840 in India and early in its career transported immigrants from England to Australia. For several years, the *Success* was used as a prison ship. A group of investors repurposed the ship with the intention of charging folks to view a "convict ship." In June 1924, the ship docked by Granada Park, and owners offered $100 to the "bravest woman in Detroit" who could spend 27 hours in the Black Hole torture cell of the ship. In converting the *Success*, owners brought aboard branding irons, handcuffs, leg irons, straitjackets, a whipping post, and a coffin-like torture contraption called the iron maiden to frighten the gullible public who were told of ghosts of dead prisoners.

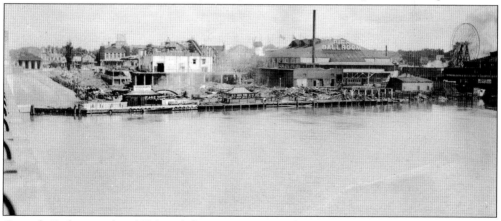

Granada Park opened in 1924, and the owners promised a family atmosphere where "thrills are provided for those who seek them, comedy for those who don't like to scare themselves to death, music for the tired businessman who only wants to loaf and smoke in pleasant surroundings, and refreshment for those who feel that it's no fun going to the circus if you can't drink lemonade and munch on crackerjack." However, after more years of lawsuits, fires, and gambling raids, the City of Detroit closed down all of the parks by condemning them in 1927. Several buildings shown in the photograph were left as rubble in 1928. (Courtesy of Burton Historical Collection, Detroit Public Library.)

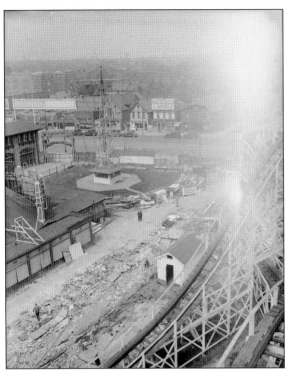

This is an overhead photograph of Granada Park (also known as Riverview Park) and the debris from its razing once condemnation proceedings started in 1927. Detroit city planner and secretary of the city planning commission Walter H. Blucher mentioned that the city had two strips of land, one on each side of the bridge, but needed more for the use of buses and decorative purposes at the entrance of the bridge. (Courtesy of Virtual Motor City Collection, Wayne State University.)

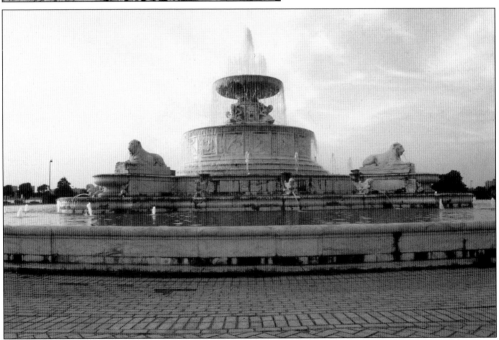

The James Scott Memorial Fountain is a monument located on Belle Isle in Detroit. Designed by architect Cass Gilbert and sculptor Herbert Adams, the fountain was completed in 1925 at a cost of $500,000. The fountain honored the controversial James Scott, who left $200,000 to the City of Detroit for a fountain in tribute to himself. Several community and religious leaders spoke against accepting the bequest, saying that a person with Scott's reputation should not be glorified in the city.

Three

JEFFERSON BEACH
AMUSEMENT PARK

Filling the area amusement park vacancy in 1927 was Jefferson Beach Amusement Park along Lake St. Clair in St. Clair Shores, Michigan, about 16 miles north of the Belle Isle Bridge. The park bragged that it had the world's largest roller coaster, a Ferris wheel, a carousel, an arcade, and a dance pavilion. People could also swim at night on the lighted beach. The park was an overnight sensation, drawing thousands to the shore. In 1918, only one in thirteen families owned a car. By 1929, four out of five families had one. In the same period, the number of cars on the road increased from 8 million to 23 million. Patrons did not mind traveling a few miles to get entertained in the park and cooled off by the lake breezes. (Courtesy of Virtual Motor City Collection, Wayne State University.)

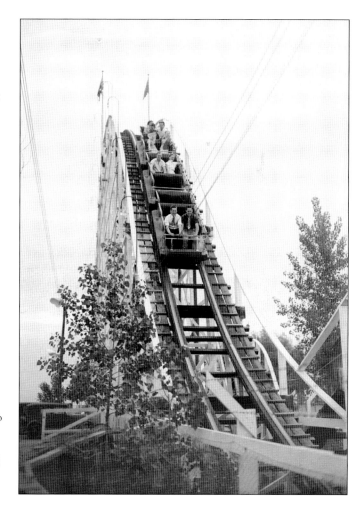

A Waltzer whirls its passengers in a rotating tub, projects them over a sudden bump, and releases the tub at high speed to slide through a dark tunnel. In 1938, only one other Waltzer was in operation out in California. Because of its popularity, the ride was brought to Jefferson Beach. This photograph shows Waltzer riders laughing as they go round and round. (Courtesy of Virtual Motor City Collection, Wayne State University.)

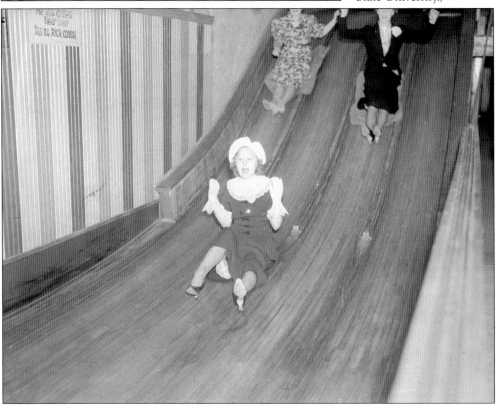

Two women and a girl in their dresses are shown sliding down a fun slide at Jefferson Beach Amusement Park. Fun slides come in different lengths and numbers of slide lanes, including the state fair's five-lane, 90.75-foot lane, and 65.75-foot lane. The ride can be made faster using a beeswax polish or can be slowed using a sugar-based soda. A coconut matting lies on the bottom of the ride to bring the riders to a safe stop. Many kids used wax paper on backyard slides. (Courtesy of Virtual Motor City Collection, Wayne State University.)

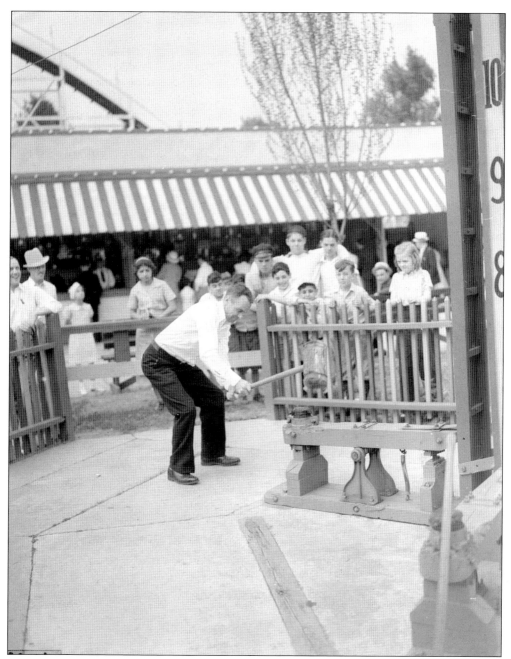

A park barker would entice patrons with phrases like, "See if you are a man or mouse," or "Step right up and show how strong you really are." This image depicts a man with a mallet giving his all striking a lever that shoots a disk to the top and rings a bell, showing he's a winner. The crowd looks on with curiosity and amazement. The high striker, also known as a strength tester or strongman game, is an attraction used in amusement parks, church bazaars, and carnivals. (Courtesy of Virtual Motor City Collection, Wayne State University.)

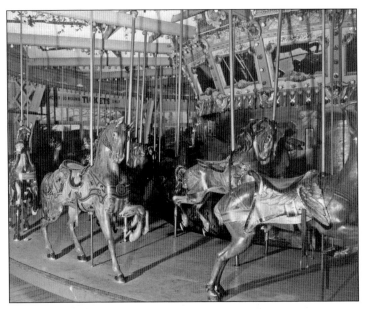

This is a close-up view of the carousel at Jefferson Beach Amusement Park. The 60-foot Dentzel carousel had painted wooden horses and was made in Germany. The ceiling had a floral design with gilded angels and mirrors in the center. The sign in the left background reads "Merry Go Round Tickets Only." The 17-acre park was located at 24400 Jefferson Avenue at Nine and Half Mile Road. (Courtesy of St. Clair Shores Historical Society.)

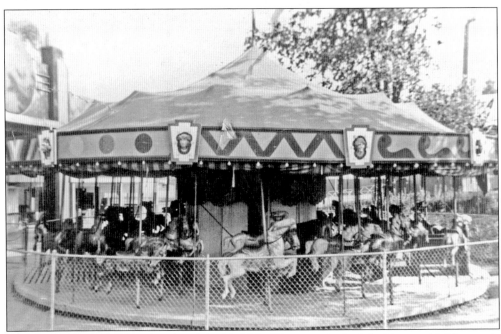

In 1928, the Dentzel carousel replaced the PTC No. 71 carousel, which had been sold. Menagerie animals were included on this merry-go-round. This is a damaged photograph of the children's merry-go-round at the park. The merry-go-round had horses and chariots for the children to ride. Note the male faces on the canopy of the ride. The history of this carousel after it left Jefferson Beach is unknown. (Courtesy of St. Clair Shores Historical Society.)

The Kiddie Land play area at Jefferson Beach Amusement Park is pictured here. The miniature amusement park in itself was designed to provide safe and appealing rides for children only. Here are kids seated two by two enjoying a mini Ferris wheel ride. The park was "real pretty," one unidentified girl said. "The entrance had flowers and all bright colors of flags on both sides of the walk in. The picnic area had swings and slides and deep, light sand. Once, I made a record at this one booth for my dad [who was] in the Army." (Courtesy of St. Clair Shores Historical Society.)

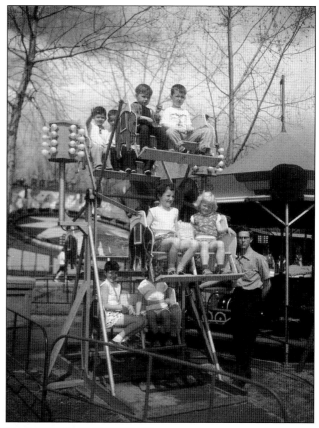

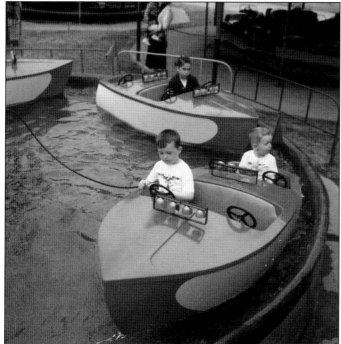

The Kiddie Land boat ride had striped awnings overhead. Boats traveled around a real water-filled tank. Other kiddie-sized rides included a Ferris wheel equipped with special safety precautions that enclosed its passengers in small baskets completely enveloped in wire mesh and doors that locked outside. (Courtesy of St. Clair Shores Historical Society.)

Seen here is car No. 2 at the Bubble Bounce ride at the park. It had teacup-type karts that one sat in and were spun with a wheel in the center of the cart. Most teacup rides were on flat tracks that went up and down pretty fast. The teacup ride is one of the most traditional and classic rotating amusement park rides. (Courtesy of St. Clair Shores Historical Society.)

Decorations line the outside of the funhouse, an amusement facility found in amusement parks and funfair midways where patrons interact with various devices designed to surprise, challenge, and amuse them. Unlike thrill rides or dark rides, funhouses are interactive attractions where visitors enter and move around under their own power. (Courtesy of St. Clair Shores Historical Society.)

Harry Stahl is seen resting in front of the arcade. Stahl was responsible for the design of the Rocket Ride and many other rides at the park. Directly behind the Rocket Ride was the funhouse. After the disastrous 1955 park fire, Stahl expanded the 20-acre, 500-boat facility at the lake end of the amusement park. He converted and doubled the facility's capacity. Eventually, the area covered 800 acres of prime beachfront property. (Courtesy of St. Clair Shores Historical Society.)

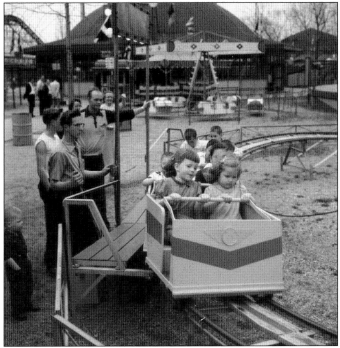

Seen here is the kiddie car ride at the park. Children's rides cost up to $15,000, which was comparable to major rides. Kiddie Land was equipped for children's parties. Small tables were set aside in a special enclosure, and loudspeakers broadcast kids' records. Groups of six or more received complimentary favors and novelty hats. (Courtesy of St. Clair Shores Historical Library.)

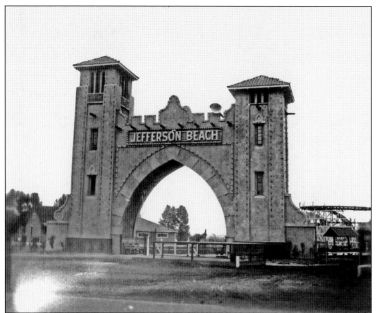

This is the Jefferson Beach Amusement Park entrance. The original arch was made of wood, and after it burned, it was replaced with this stone structure. The park boasted that it was a safe beach with 600 feet of white sand in contrast to the health department warning of pollution of the Detroit River and overcrowding on Belle Isle, which was miles to the south. (Courtesy of St. Clair Historical Society.)

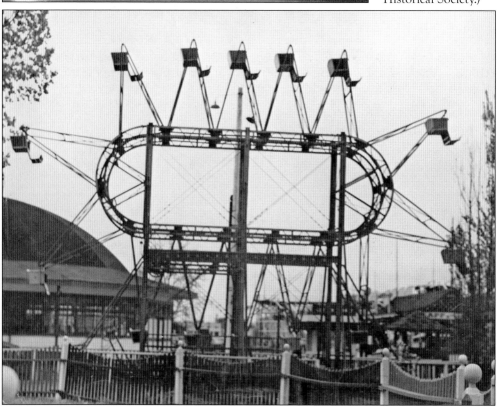

The Swooper was the park's original wheel ride and unique because of its oval shape. A Ferris wheel rotated and the cars swung free, but the Swooper did not. The cars remained stationary while steel cables pulled the seats attached to steel brackets in an oval shape. The ride was easy to load and unload patrons, but it made them often queasy. (Courtesy of St. Clair Shores Historical Society.)

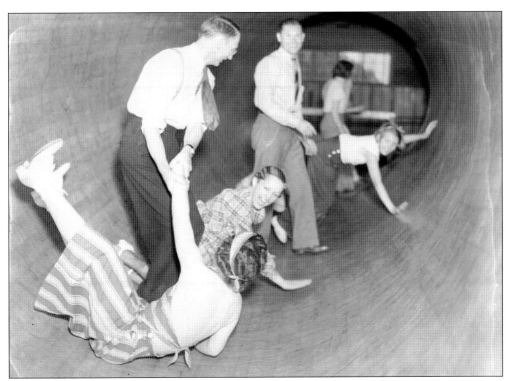

Funhouse patrons would often try going on a horizontal revolving cylinder or barrel, sometimes called "barrel of love" or "barrel of fun," to try and walk through it without falling. According to Nancy J. Dyer Gealow, "From the moment my father set foot in the barrel it was a disaster. He wiped out six people and squashed my sister's head. They were rolling around like tumbleweeds in a ghost town." (Courtesy of Virtual Motor City Collection, Wayne State University.)

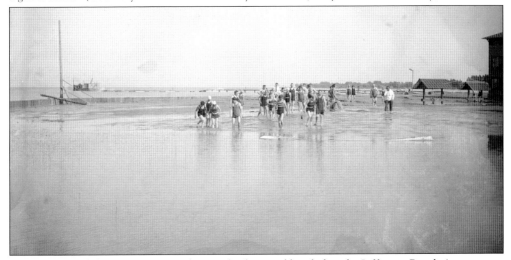

Families packed their swimsuits and picnic baskets and headed to the Jefferson Beach Amusement Park on Lake St. Clair in droves once school let out in June. The sandy beach and cool breezes were a main attraction for parkgoers hoping for relief from a hot summer day. The area was free from the water pollution often found south closer to the city of Detroit. (Courtesy of Virtual Motor City Collection, Wayne State University.)

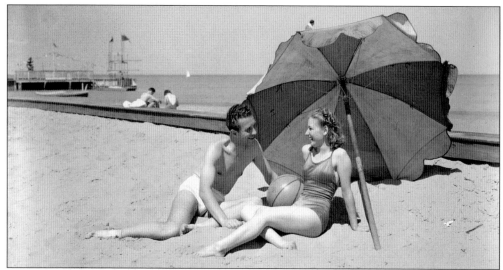

For many years, Lake St. Clair Metropark has been known as "Metro Beach" because of its 1,000 feet of beach area that runs along the shore of Lake St. Clair. This 770-acre park, located only 20 miles from downtown Detroit, offers a variety of recreational activities such as bird watching, windsurfing, boating, bicycling, and swimming. Lake St. Clair Metropark also features an Olympic-sized pool and a Squirt Zone that kids cannot get enough of. A couple enjoys lying out on the sand near where the Jefferson Beach Amusement Park was located. (Courtesy of Virtual Motor City Collection, Wayne State University.)

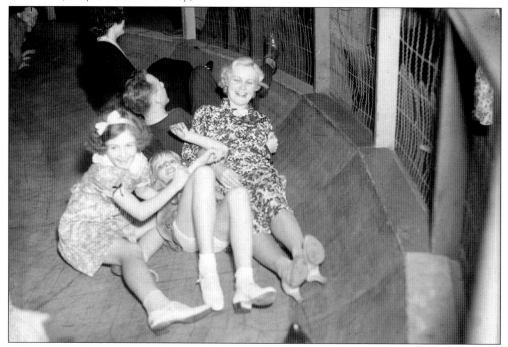

Mom, dad, and the kids enjoy the wooden Panama Slide. Note how well-dressed they are. Jefferson Beach Amusement Company promised to provide clean, safe, and wholesome recreation for everyone. It also offered to fill the hearts of children with joy while they spent their hours of play in the sunshine and fresh air. (Courtesy of Virtual Motor City Collection, Wayne State University.)

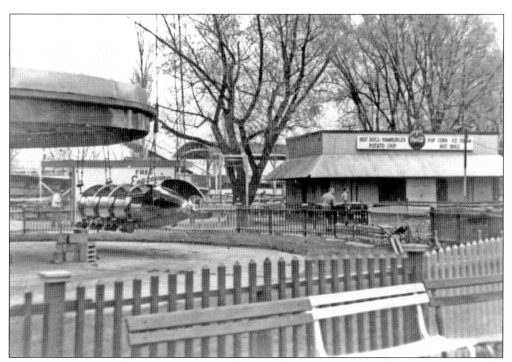

A concession stand and the Rocket Ride are shown with an engraving stand in the background. Ed Bailey, secretary of the Jefferson Beach Amusement Company, said the park would be the "most complete amusement center within reach of the entire Detroit area. No expense is being spared to equip it throughout in the most modern way." (Courtesy of St. Clair Shores Historical Society.)

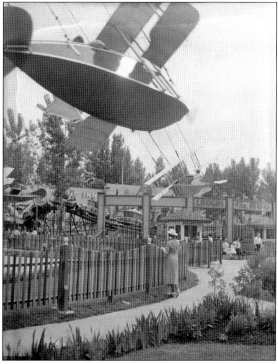

A solitary mother waits for her kids to complete the Stratoship ride. Opened in 1927, Jefferson Beach Amusement Park was often plagued by gambling outbreaks, complaints from neighbors about noise, and rowdy behavior of some parkgoers. After the 1955 fire wiped out so many rides, the park limped along until St. Clair Shores officials had enough and revoked the company's license to operate an amusement park on the site in 1959. (Courtesy of Virtual Motor City Collection, Wayne State University.)

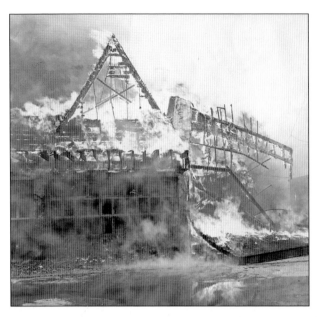

The shooting gallery is completely going up in flames. When this photograph was taken, the building was engulfed in fire. Note the roof is already missing. Although the park remained open for another three years, it was the beginning of the end. The park business began changing in the mid-1950s to include about 500 boat well facilities, and the focus of operations became the sale of boats and marine equipment. A marine gasoline service station and facilities to service boats were constructed. With the successful birth of this full-scale marina, the business closed as an amusement park in 1959. (Courtesy of the St. Clair Shores Historical Society.)

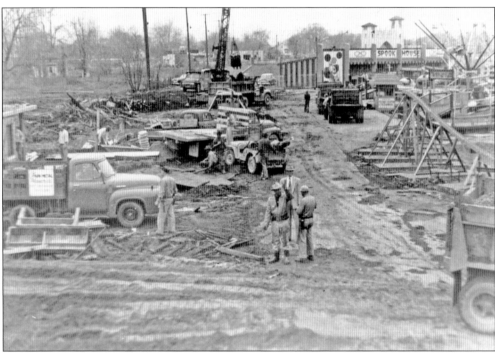

Workers sort through what is left of the amusement park after the April 15, 1955, fire destroyed most of it. The remaining park structures were razed during that summer, and the expansion of the marina was speedy. Today, Jefferson Beach Marina offers few clues about the amusement park that once existed there. However, for those who have been around for a few years and grew up east of Woodward Avenue, chances are they still have fond memories of a visit to Jefferson Beach at least once in their youth. (Courtesy of St. Clair Historical Society.)

Four

MICHIGAN STATE FAIR

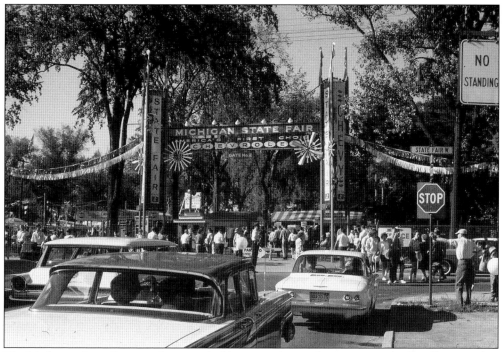

The Michigan State Fair was the second oldest state fair in the country and officially opened in 1849. The Michigan State Fair operated in several Michigan cities until 1905, when retail giant J.L. Hudson purchased property at Woodward Avenue and Eight Mile Road. Hudson then sold the site to the Michigan State Agricultural Society for $1. Besides farmers winning blue ribbons for livestock and produce, there was entertainment that ranged from carnival rides to games, contests, and exhibitions and live performances from big band leaders to Motown musical acts. It was a state fair and amusement park all rolled into one. After declining attendance in 2009, the fair was not held for two years. In April 2012, Gov. Rick Snyder signed a bill to authorize the Land Bank Fast Track Authority to oversee future land development. Because the agriculture industry was the second largest in the state, many people were distressed by the state's lack of support. The Great Lakes Agricultural Fair was organized in 2011, and its first fair took place from August 31 through September 3, 2012, in Novi, Michigan. It is now called the Fifth Third Bank Michigan State Fair at the Suburban Collection Showplace in Novi.

These helicopter ride passengers have control over their vehicles. By pulling back on the control bar, their copter takes flight. They push forward, and they land again. An adult may ride with a child in each helicopter, making it an interactive adventure. The Allan Herschell Company built this ride. (Courtesy of John Martin Strauss.)

The Sky Wheel featured two Ferris wheels attached to opposite ends of a large boom that rotated in the air. One rider remembers "the squealing of the tires as it let passengers on, and the green and yellow lights would light up the midway at night. It has definitely earned its name. 'King of the Midway.' I could ride the Sky Wheel all night long!"

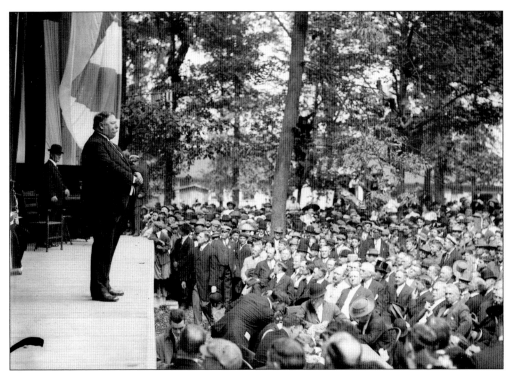

President of the United States William Howard Taft stands among a group of unidentified men during a September 18, 1911, visit to the Michigan State Fair in Detroit. Over 10,000 packed the bandstand with another 15,000 on the fairgrounds. "During his long government career, he served as Governor to the Philippines, Secretary of War, President of the United States and Chief Justice of the U.S. Supreme Court, he is the only man in U.S. history to have been both president and chief justice," according to the Arlington National Cemetery website. (Courtesy of Virtual Motor City Collection, Wayne State University.)

Ulysses S. Grant was transferred in the spring of 1849 to the Detroit Barracks as quartermaster of the 4th Infantry. Grant and his wife, Julia Dent Grant, lived in this house from April 1849 to May 1850. The home was moved in 1936 to the Michigan State Fairgrounds. In 1959, his 80-year-old grandson Maj. Gen. Ulysses S. Grant III helped rededicate the restored Grant House at the fair. (Courtesy of Wayne State University Motor City Collection.)

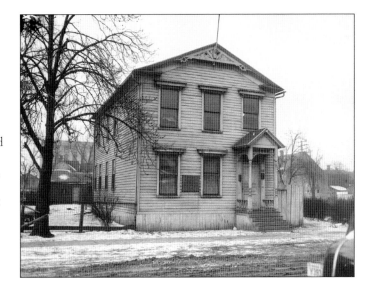

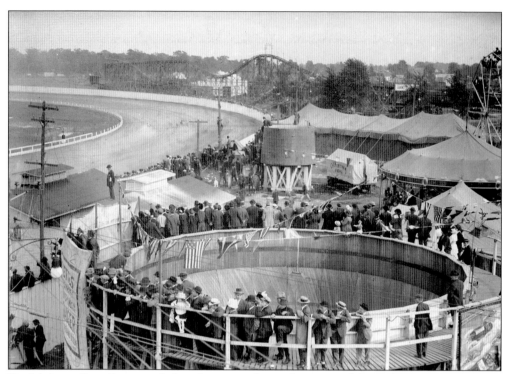

The Michigan State Fairgrounds Speedway was a dirt oval racing track located in Detroit. The track was built in 1899 for horse racing, and it was part of the grounds purchased to provide a permanent venue for the Michigan State Fair. By 1908, the racetrack, at the east end of the fairground, had a 5,600-seat-capacity grandstand. (Courtesy of Virtual Motor City Collection, Wayne State University.)

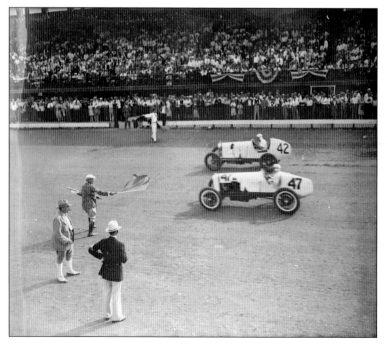

NASCAR ran two races at the fairgrounds in 1951 and 1952. The city of Detroit celebrated its 250th anniversary by teaming up with NASCAR to promote the 1951 race, which was won by Tommy Thompson of Louisville, Kentucky, in a 1951 Chrysler New Yorker. In 1971, the grandstand was declared unsafe; it was demolished in 2001. (Courtesy of Virtual Motor City Collection, Wayne State University.)

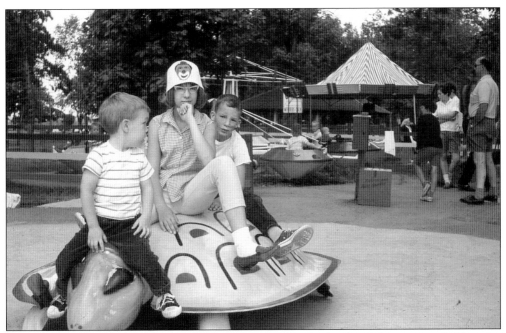

Three Strauss children (from left to right, Dan, Tricia, and Al) take a break from various kiddie rides while sitting together on a stand-alone turtle. The turtle was made from metal and fiberglass. A typical kiddie ride is shown in the background. Other kid activities included a pie-eating contest, balloon blowing, sack races, baton twirling, and a longest ponytail contest. (Courtesy of John Martin Strauss.)

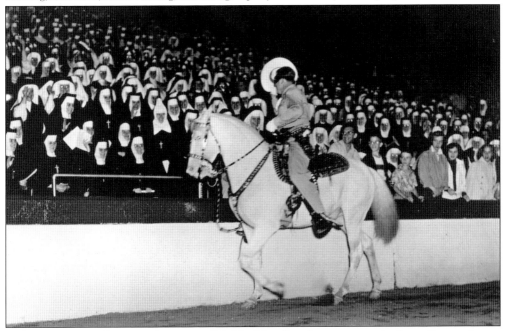

Radio actor Brace Breemer shouts out "Hi Ho Silver!" as he arrives as the Lone Ranger for an audience of boys, girls, and nuns at the Michigan State Fair Coliseum. Breemer became the face of the franchise because of his six-foot, three-inch frame, authoritative voice, and ability to ride a horse. (Courtesy of Detroit Public Library.)

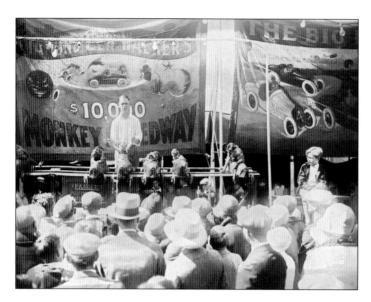

It is a fact that the general public loves performing animals in unique situations. This may explain the great popularity of the Monkey Speedway. Monkeys sat in specially designed miniature cars that ran on beveled wheels on a roller coaster–type gravity track. The races were quite lively, with everyone rooting and cheering for their particular favorite. (Courtesy of Virtual Motor City Collection, Wayne State University.)

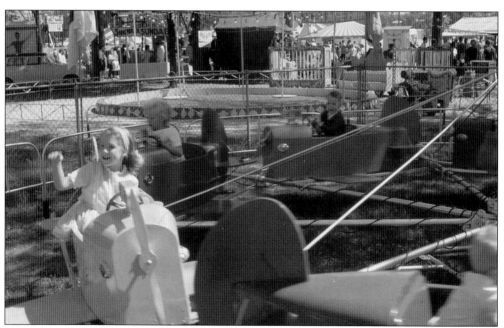

Sky Fighter was an immediate success at the locations where it was installed. Buzzers on the fighter plane guns added to the fun. Note the lion's cage in the background. (Courtesy of John Martin Strauss.)

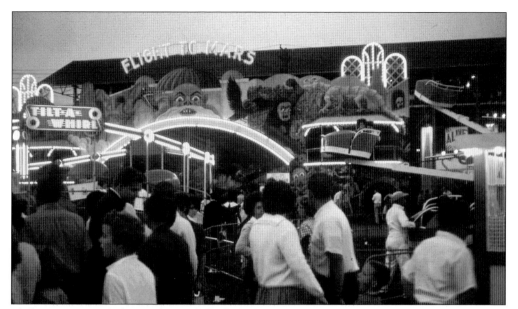

Flight to Mars was the best and most chill-filled ride for many kids at the Michigan State Fair. Leering, gap-toothed gargoyles from space covered the exterior walls, portending further spine tingles and terrors within. The beetle-shaped cars were two-seaters, and riders clutched the restraining bar as the car lurched forward and clattered through swinging doors into darkness visible.

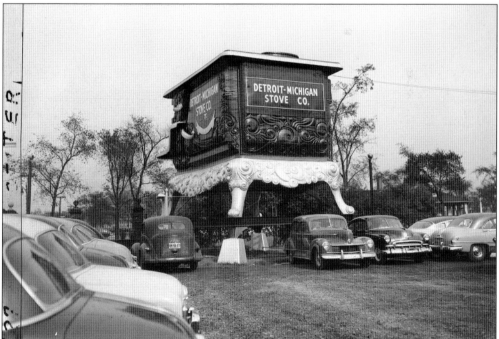

The Michigan State Fairgrounds housed the world's largest stove, which was built by the Michigan Stove Company for the World's Columbian Exposition in 1893 in Chicago. The 25-foot-tall, 15-ton stove was shown at the fair in 1965 and fell into disrepair, spending years in storage until it was restored and brought back in 1998. (Courtesy of Virtual Motor City Collection, Wayne State University.)

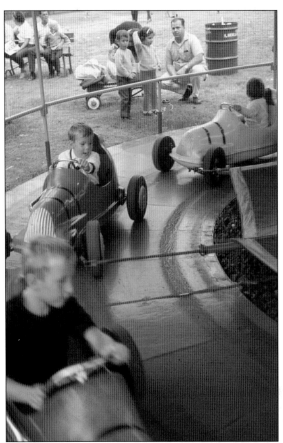

Children go round and round on kiddie racing cars by Wade Shows, Inc. It is a traveling carnival midway company based in Livonia, Michigan, that provides amusement rides, games, and concessions for local, county, and state fairs throughout the eastern and central United States. The company also has an office in Spring Hill, Florida, the location of its winter quarters. Wade Shows was founded in 1912 by Leander "Lee" Wade. (Courtesy of John Martin Strauss.)

The Tip Top is a classic amusement ride that consists of a large turntable with free-spinning vehicles. As the turntable begins to spin, the ride platform bounces up and down in the air, resulting in a unique experience for riders. This spinning ride is extremely dizzying because of how easy the tubs are to spin. Note the grandstand to the left.

Herbert Sellner invented the Tilt-A-Whirl in 1926 at his Faribault, Minnesota, home. In 1927, the first 14 Tilt-A-Whirls were built in Sellner's basement and yard. Some of the rides produced in the 1940s and 1950s are still in operation. The earliest Tilt-A-Whirls were constructed of wood, powered by gas motors, and featured nine cars.

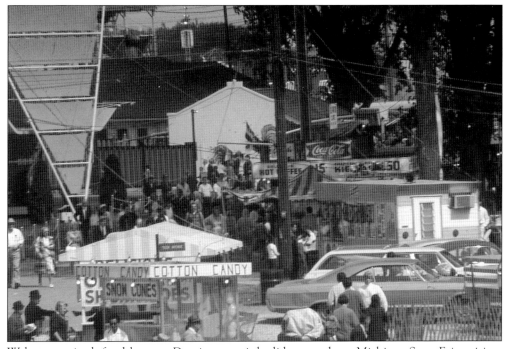

Welcome to junk food heaven. Dentists certainly did not endorse Michigan State Fair cuisine, but fairgoers did. Food vendors provided everything from snow cones and cotton candy to pizza, hot dogs, hamburgers, ice cream, funnel cake, Polish sausages, candy apples, popcorn, corn dogs, elephant ears, peanuts, pretzels, french fries, barbecue, and chicken. Popular drinks included soda pop, beer, and freshly squeezed lemonade.

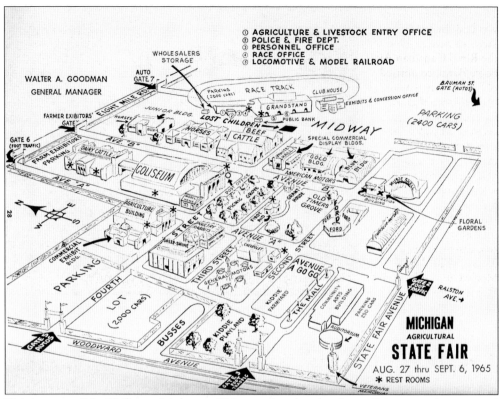

This is a map of the 1965 state fair layout. This state fair closed with an all-time attendance record of 1,090,206. A new attraction that year featured the Avenue A Go Go. The Community Arts Building was also added to accommodate rock-and-roll bands, folk singers, a sound stage, fashion shows, and related talks, according to the book *Michigan State Fair Memories*.

The 150-acre site had an area for a children's petting zoo and pony rides. Animals in the petting area included chicks, pigs, lambs, ducklings, rabbits, and baby goats. Kiddie Playland was added to the state fair in 1954 and was designed for children 12 and under. There was a playground, carousel, and activities center for kids. The Kiddie Barnyard was added in 1955.

The open-air bandshell was built in 1938. Pictured here in 1960 is the Royal Canadian Air Force Band, comprised of 54 men who could play any sort of music from a full-dress ceremonial parade to a modern symphonic band concert, a variety of dance bands, or a salon group suitable for background music. The music shell always provided free entertainment. (Courtesy of Virtual Motor City Collection, Wayne State University.)

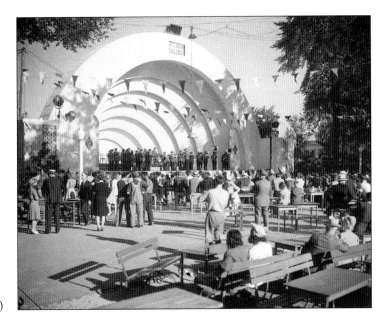

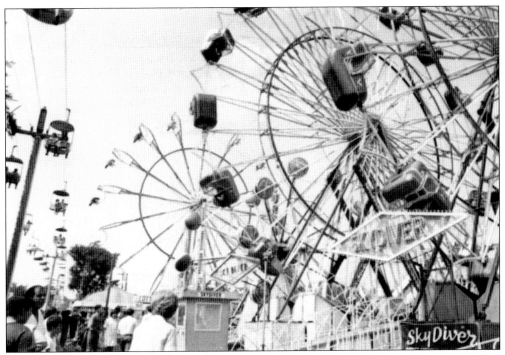

Sky Divers were a 1960s-era Chance Rides creation that were seen virtually everywhere back in their heyday and up until 1994 or so, when they went through a mass extinction of sorts. Sky Diver sports small caged pods that can rotate horizontally while the wheel turns vertically. The small caged cars are equipped with a steering wheel that allows riders to effectively make their own ride experience by flipping the car around. (Courtesy of Virtual Motor City Collection, Wayne State University.)

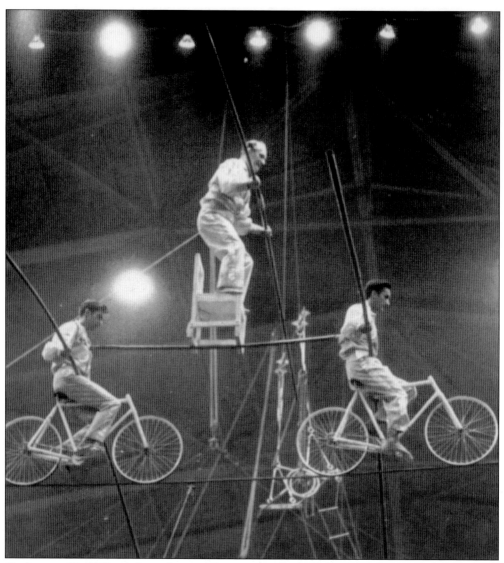

On January 30, 1962, while performing their seven-person chair pyramid signature stunt for the Shrine Circus at Detroit's State Fair Coliseum, the lead man on the wire—Karl Wallenda's nephew Dieter Schepp—made a misstep that caused the entire pyramid to collapse as an audience of nearly 7,000 watched in horror. Four crashed to the ground: Schepp and Karl Wallenda's son-in-law Richard Faughtnan, who both died on impact; Karl's son Mario, who was permanently paralyzed from the waist down; and Karl himself, who suffered a broken pelvis. In a real display of the show going on, the surviving members of the Flying Wallendas performed again in the same venue the very next day. (Courtesy of *Detroit Free Press*/Zuma Press.)

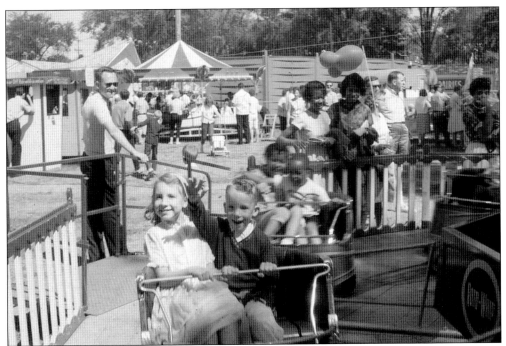

The Whip was a ride originally designed and built by W.F. Mangels Company of Coney Island, New York. William F. Mangels patented the ride in 1914, and it soon became extremely popular. A children's version (seen here) was also built that looked exactly like the full-size version. A children's Roto-Whip was also produced and features a circular motion that whips the cars as it goes around. (Courtesy of John Martin Strauss.)

Wade Shows Midway has dozens of rides designed with family thrills in mind like old favorites such as the Tilt-A-Whirl and Scrambler. When it comes to children, one can find bears, dragons, and monkeys at a Wade Shows Kiddie Land. Wade Shows provided customers with a park-like atmosphere with landscaping, shaded rest areas, midway signage, and a complete guest relations center. (Courtesy of Virtual Motor City Collection, Wayne State University.)

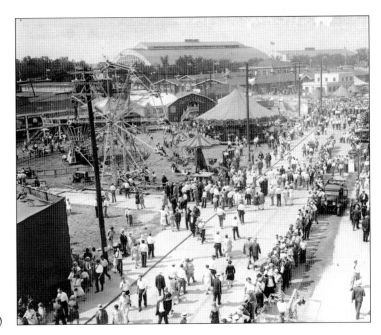

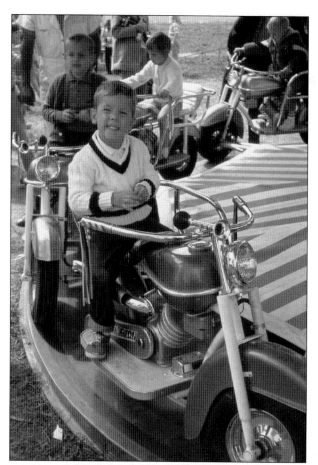

This classic Hampton motorcycle umbrella-top flat ride offers a safe carousel type of experience for kids. Children can drive smoothly around a circular track and honk the horn for some extra fun. Dan Strauss seems to have his ride on autopilot. The motorcycles have a very authentic look to them. (Courtesy of John Martin Strauss.)

The Michigan State Fairgrounds Coliseum was a 5,600-seat multipurpose area built in 1922. Besides hosting the Shrine Circus for years, the coliseum held many concerts, with the first known one on New Year's Eve 1941. The concert featured Jan Savitt, who was known as "the Stokowski of Swing." Other stars who performed there over the years include Louis Armstrong, Tommy Dorsey, the Ink Spots, and Bill Haley and the Comets, among others. (Courtesy of Roberto Huston.)

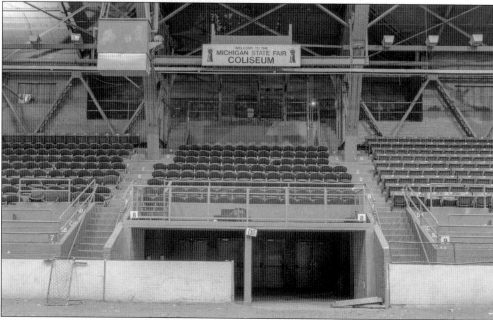

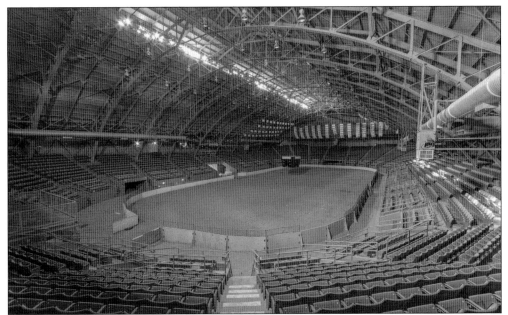

The Michigan State Fairgrounds Coliseum hosted three Extreme Championship Wrestling shows between 1999 and the middle of 2000. From 1999 to 2008, the Wayne State University Warriors ice hockey team called the coliseum home after renovations were completed. The coliseum also hosted the 2006 men's and women's College Hockey America conference tournaments. In 2020, the state fairgrounds were sold to Amazon, and the company plans to build a $400-million distribution center on the site. (Courtesy of Roberto Huston.)

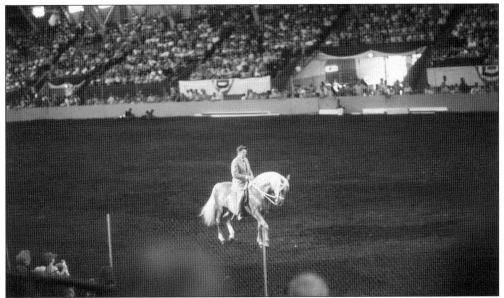

The coliseum was also used for horse shows, rodeos, and different competitions like the judging of the Grand Champion steer. One competition, shown here, is dressage, what some people call "horse dancing." Dressage is an equestrian sport defined by the International Equestrian Federation as "the highest expression of horse training" where "horse and rider are expected to perform from memory a series of predetermined movements."

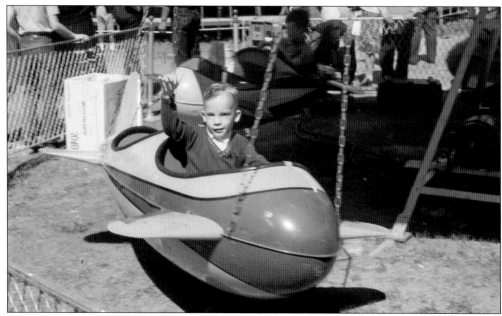

This is another Allan Herschell ride that was part of an original Kiddie Land package that debuted in 1952. Allan Herschell marketed this ride as the Sky Fighter, and it was an immediate success at the locations where it was installed. Youngsters are gently lifted into the air and fly in a circular motion in two-seat jet fighters that resemble something out of *Flash Gordon*. Al Strauss waves to his dad from the cockpit. (Courtesy of John Martin Strauss.)

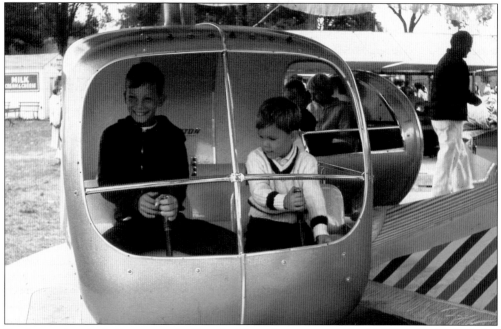

Brothers enjoy the helicopter umbrella ride. The ride was created by Ted Snead, who built his first amusement park ride from spare parts in 1942 on a St. Louis street called Hampton Avenue. Hampton Amusement Company became a very popular manufacturer of kiddie rides in the 1960s and 1970s. Many Hampton rides are still in operation today. (Courtesy of John Martin Strauss.)

Five

WALLED LAKE
AMUSEMENT PARK

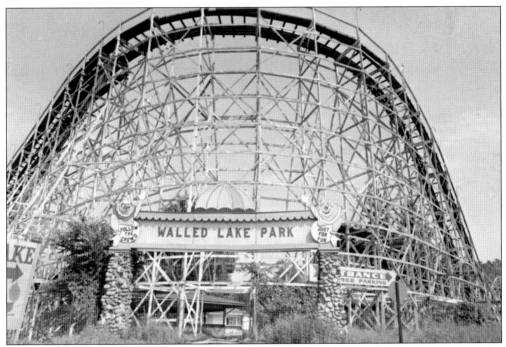

Situated in the sleepy town of Walled Lake, this park was created in 1929 by Fred W. Pearce, who leased the property from Herman Czenkusch. Louis Tolettene became the owner when Czenkusch died in August 1929. When the Great Depression left Tolettene broke, he got a loan from Walled Lake resident Mrs. Richardson, and his dance hall, known as the Walled Lake Casino, thrived. Tolettene's family took over running the park after he died in June 1936 with great success until they closed during World War II. The ballroom closed in 1960, reopened under new management in 1962, and eventually switched from big band to rock-and-roll acts, with heating installed for year-round dancing. After another ownership change, the casino was destroyed by fire on Christmas Eve 1965. Fred Pearce Jr. took over running the amusement park when his dad died in the early 1960s. Pearce Jr. sold the park to the Wagner brothers, who also operated Edgewater Amusement Park in Detroit. With the park in disrepair in 1968, the Wagners tore down and relocated most of the rides to Edgewater Park, ending 50 years of entertaining men, women, and children from the area.

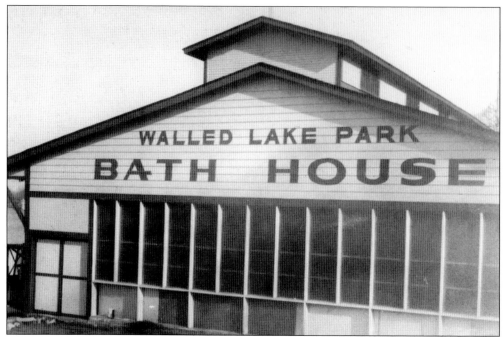

Originally, Walled Lake was one of the stops on the Underground Railroad where slaves escaped the South for their freedom. In the early 1900s, Jake and Ernest Taylor built a small dance hall and bathhouse near their general store at the south end of the lake. Soon, 1,000 people came to dance the night away to music by big bands. Simultaneously, Herman Czenkusch also built a huge bathhouse and a two-story wooden slide called the Cenaqua Shores Toboggan and Bath House. (Courtesy of Novi Public Library.)

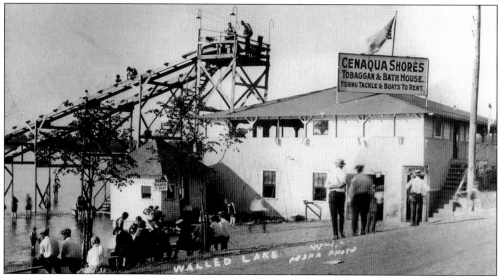

In 1921, Czenkusch built the Cenaqua Shores Dance Pavilion to compete with the Taylors' dance hall. He also installed a restaurant and showed movies there as well. The pavilion burned down in November 1921, but Czenkusch rebuilt it larger and fancier than ever. The Taylors could not compete for long and sold their bathhouse and dance hall to Louis Tolettene. He, in turn, opened a remodeled facility named Casino Shore Dance Pavilion in April 1923. (Courtesy of the Novi Public Library.)

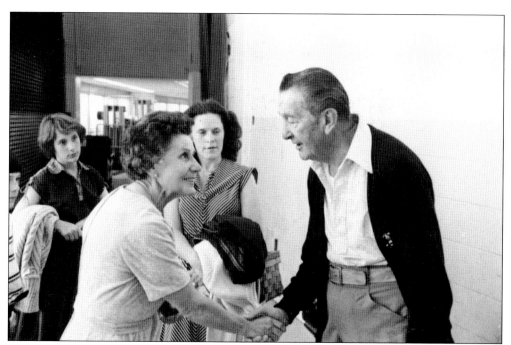

One of the lots sold along East Lake Drive belonged to bandleader Lawrence Welk, who purchased the property for his family to stay in when he and his orchestra played during summers at the New Casino Ballroom at Walled Lake. His signature sound was called "champagne music." Welk had a national television show that broadcast from Los Angeles from 1951 to 1982. He is shown here greeting his fans. (Courtesy of Virtual Motor City Collection, Wayne State University.)

In 1929, a roller coaster christened "the Flying Dragon" was built by Fred W. Pearce, and it was his crowning achievement with its 60-mile-per-hour dive. Because Pearce had an interest in having a park of his own, he made a deal with Herman Czenkusch to lease his property and went to work on constructing the Walled Lake Amusement Park. The park opened on May 9, 1929 (Memorial Day), and was an instant success. (Courtesy of Novi Public Library.)

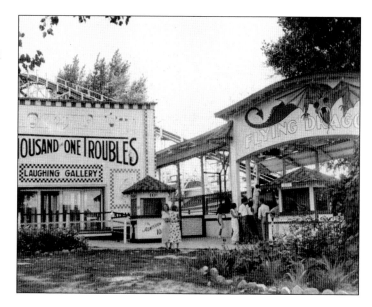

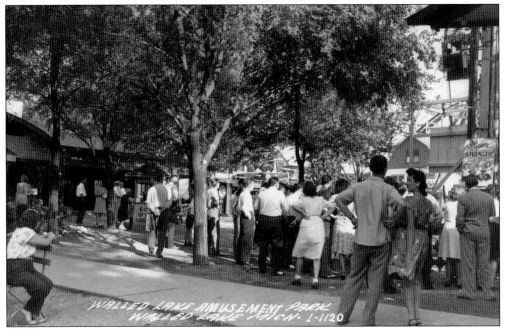

Crowds mill around the Guest Your Weight stand and the Test Your Strength and Skill exhibition. Note how dress styles changed over the years from more formal before the war to after, when folks wore more casual clothing. The Walled Lake Amusement Park was a smash hit from the start and attracted large crowds from the very beginning with a variety of attractions. (Courtesy of Novi Public Library.)

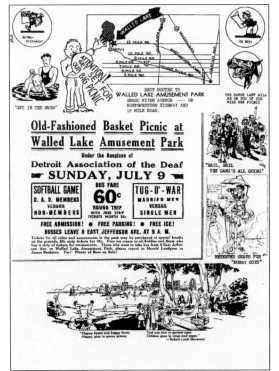

Advertisements boasted that "Walled Lake Park is the Picnic Wonderland." Picnics were a large source of park income. Many schools, businesses, and civic organizations had group outings there. Having picnic lunches at Walled Lake became a summer tradition for many of them. Quite often, there were special events or games specifically staged to attract picnicgoers. Pie-eating and tug-of-war contests were common sights. Ice cream was free to all kiddies. (Courtesy of Novi Public Library.)

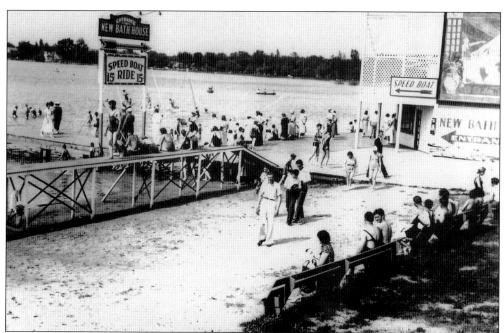

The casino and park installed playground equipment along a boardwalk that went 500 feet from the bathhouse to the shallow water of Walled Lake. The children's swimming area offered a place for the kids to splash, swing on swings, and play on teeter-totters in shallow waters. In its salad days, Walled Lake was one of the most popular destinations in all of Michigan. (Courtesy of Novi Public Library.)

In the early 1900s, engineer Harry Traver was recovering from diphtheria aboard a cattle boat when he saw a flock of seagulls circling the boat mast and got his first ride idea: the circle swing. This ride was 80 feet high and served as a model for the many amusement rides he invented throughout his life. The cars were first shaped as elegant seats but later took the shape of airplanes and rockets. (Courtesy of Novi Public Library.)

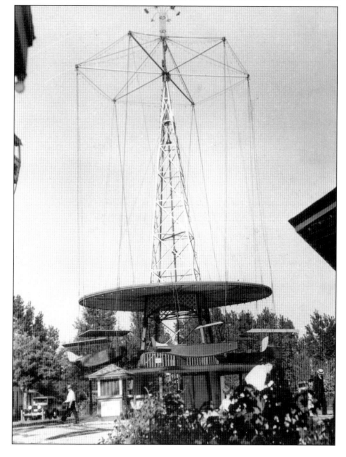

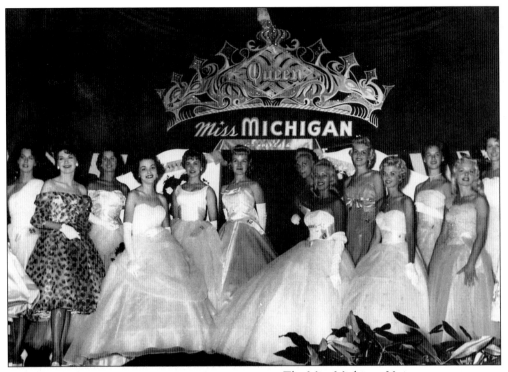

The Miss Michigan Universe contest was held July 5–7 at the Walled Lake Amusement Park in 1959. Susan Westergaard, a Southfield receptionist at John Robert Powers Modeling School, was named Miss Michigan Universe and qualified for the national finals on July 26 in Long Beach, California. An estimated 20,000 people witnessed the competition (Courtesy of Novi Public Library.)

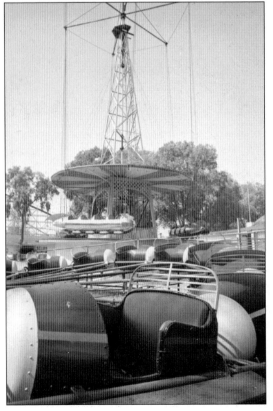

The circle swing dates back to 1907. The ride featured a 90-foot-tall tower structure in the middle from which a set of swings was suspended. Inventor and engineer Harry Guy Traver (1877–1961) also created an "amusement apparatus" with C.W. Nichols, patented in 1904, that became known as the Traver Circle Swing. The Traver Rocket Ship circle swing is seen here in the background. (Courtesy of Virtual Motor City Collection, Wayne State University.)

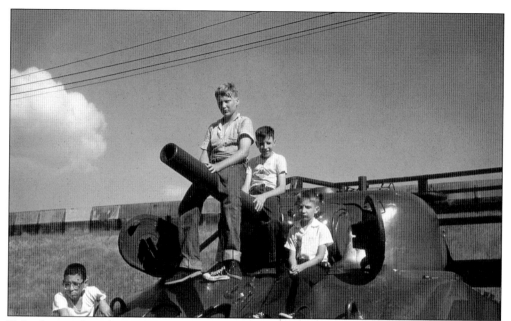

Kids clamor aboard a tank and other military vehicles at one of the Army Ordnance Project automotive expositions at the Walled Lake Amusement Park. Online videos show a tank rumbling along a dirt road at the Walled Lake Park. Military vehicles, armored cars, and tanks were on display and would demonstrate maneuvers for the crowds. The Army Ordnance Tank-Automotive Command sank $3.5 million into state industries in 1961.

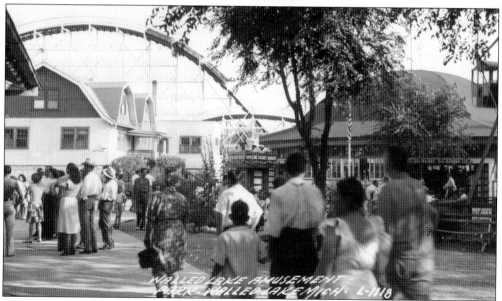

Park patrons stroll by the park office with the Flying Dragon roller coaster in the background. Large picnic crowds sponsored by auto companies often filled the amusement park. On July 25, 1937, a crowd of Dodge Main workers and their families drew 50,000 in attendance. Pontiac Motor Company had more than 20,000 employees and their families entertained at Walled Lake in July as well. They had a concert by the Pontiac Motor Band, a parachute jump, boxing matches, and softball games. (Courtesy of Novi Public Library.)

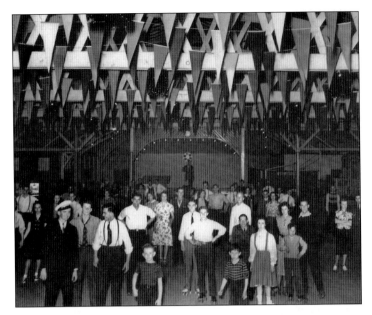

Roller Skating Rink Operators Association (RSROA) was formed in 1937 by 17 rink owners to combat the unsavory reputation the sport had gained. They established dress codes and personal conduct behavior in the hope of regaining a family atmosphere on the rinks. One can see from the photograph how smartly dressed the skaters are at Walled Lake. Skaters were often accompanied by big bands playing on stage. (Courtesy of Novi Public Library.)

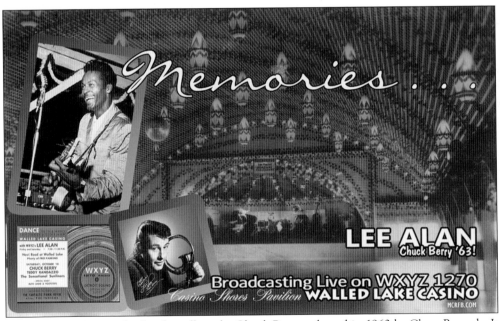

Chuck Berry on Stage is the first live album by Chuck Berry, released in 1963 by Chess Records. It is a collection of previously released studio recordings (except for five songs: "All Aboard," "Trick or Treat," "I Just Want To Make Love To You," "Still Got The Blues," and a previously unreleased alternate take of "Brown-Eyed Handsome Man"). The five live songs were recorded at the Walled Lake Casino during a program hosted by local WXYZ disk jockey Lee Alan. (Courtesy of Jim Feliciano's Motor City Radio Flashbacks.)

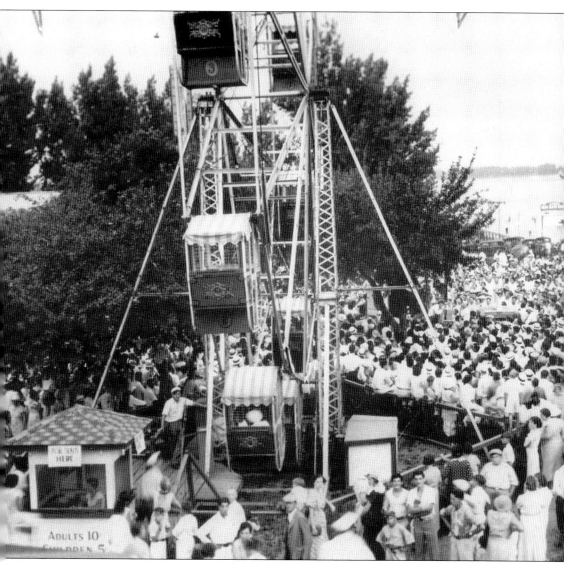

The miniature kiddie Musical Ferris Wheel was a hit with adults and kids. Touted as a "spectacular and super safe ride," the mini Ferris wheel was "barrels of fun for the small fry." This was one of many rides created by William F. Mangels, who was born in 1866 in Germany and immigrated to the United States in 1882, settling in Brooklyn, New York. He started manufacturing carousels in 1910. (Courtesy of Novi Public Library.)

A personal appearance by CKLW Channel 9's *Popeye and Pals* stars Poopdeck Paul (Paul Allan Schultz) and Captain Jolly (Toby David) was a big Memorial Weekend hit in May 1958 at the Walled Lake Park. Sponsored by Bit-O-Honey, all rides were 5¢ with a candy wrapper that day. There was also a gigantic fireworks display on Decoration Day, the very next day they appeared. (Courtesy of Detroit Historical Society.)

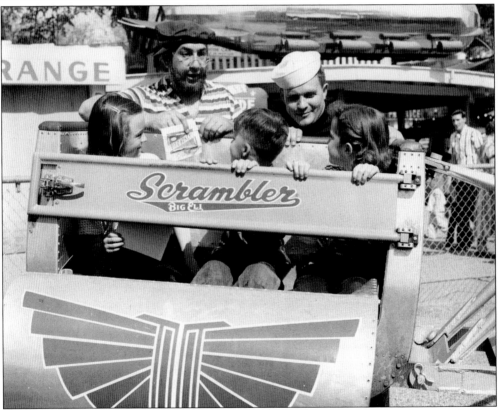

In 1957, CKLW bought the Detroit TV broadcast rights to 234 Max Fleischer and Famous Studios Popeye cartoons from Associated Artists Productions. CKLW-AM radio veteran Toby David portrayed Captain Jolly, and CKLW-TV's weatherman Paul Allen Schultz was tapped as his first mate, Poopdeck Paul. *Popeye and Pals* debuted in February 1958. Captain Jolly and Poopdeck Paul ride the Scrambler with lucky children. (Courtesy of Detroit Historical Society.)

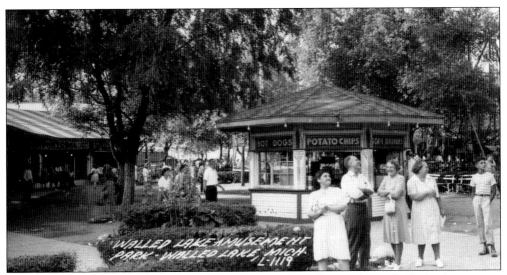

These family members are all smiles as they take in the atmosphere at the Walled Lake Amusement Park. The Pokerino game is on display to the left, with jewelry on sale next door. Concessions like hotdogs, soft drinks, and potato chips (shown in the background hut) were in ample supply for folks who did not pack a picnic lunch or dinner. A cacophony of sounds and aromas surrounded visitors to the park. (Courtesy of Novi Public Library.)

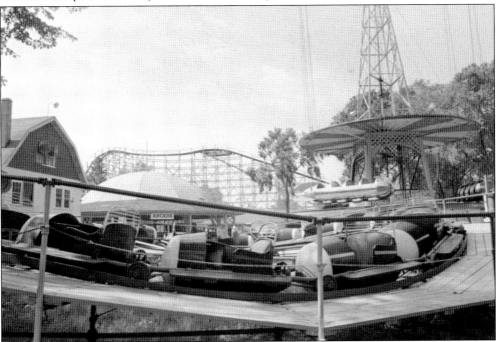

The Caterpillar ride is a vintage flat ride engineered by the inventor Hyla F. Maynes of North Tonawanda, New York, who dubbed it the Caterpillar when it debuted in Coney Island, New York, in 1925. It became one of the most popular rides at the Walled Lake Park. Caterpillar rides were made by several old amusement ride producers like Traver Engineering (famous for the Tumble Bug), Allan Herschell, and Spillman Engineering. (Courtesy of Virtual Motor City Collection, Wayne State University.)

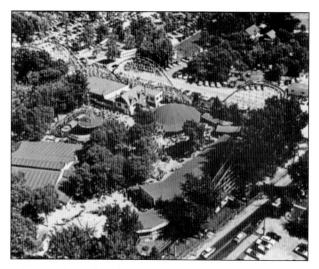

This overview of the Walled Lake Amusement Park looks south with 13 Mile Road visible just beyond the Flying Dragon roller coaster. Packed into the 12-acre site were a bathhouse, beach, and water slide along with Ferris wheels, various concession stands, two 500-foot boardwalks, a casino that held between 2,100 and 4,100 people for musical events, and speed boats for rides around Walled Lake, plus rides like the Scrambler, Pretzel, Tilt-A-Whirl, Rocket, Whip, and Michigan's tallest roller coaster, the Flying Dragon. (Courtesy of Novi Public Library.)

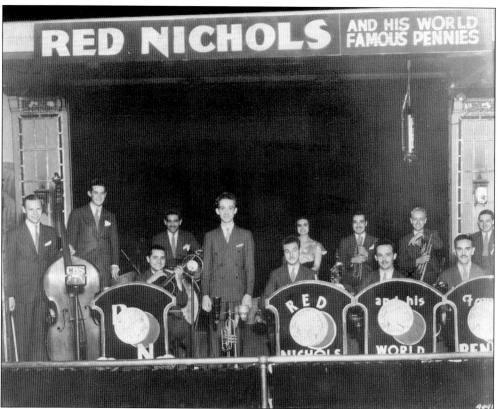

The Roaring Twenties gave way to the Great Depression in the 1930s, and the Walled Lake Casino became even more popular with big band music by Red Nichols, Benny Goodman, Louis Armstrong, and Guy Lombardo. Live radio broadcasts spread the casino's fame nationwide and kept it open while many other venues closed down. Columbia Broadcasting stars Red Nichols and his World Famous Pennies Recording Band (along with ballroom dancing) were a nightly attraction except on Mondays and Tuesdays during 1934. Nichols's music was described as "jazz at its greatest point of refinement" by jazz writer Richard Sudhalter

After attendance started dwindling in the early 1960s, the casino was sold to Red Cramer, who installed a rock-and-roll format. Remote radio broadcasts by local rock deejay Lee Allan and live performances by a variety of stars brought out capacity crowds once again. Fabian Forte headlined Clark's traveling all-star show in the mid-1960s. Over 5,000 turned out to see Fabian at Walled Lake, while hundreds had to be turned away.

On Christmas Eve 1965, around 11:30 p.m., after teenagers had gone home, a smoldering cigarette placed in a cardboard trash bin caused a fire that spread to the casino ceiling, across the lattice work, and consumed the dance floor as well as the rest of the building. The Novi Fire Department plus six community fire departments with over 100 men and 20 pieces of equipment battled the wind and flames to no avail.

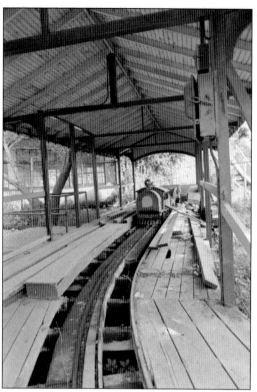

It looks like the last train is leaving the station as the Walled Lake Amusement Park closes down in 1968. The owners (the Wagner brothers) saw the rest of the park fall into disrepair after the casino fire and dismantled many rides that were bound for their other venture, Edgewater Park in Detroit. (Courtesy of Novi Public Library.)

Pavilion Shore Park is an 11-acre park that opened on August 24, 2013. The park consists of walking paths, a fishing pier, a picnic plaza, a playground, a pavilion, parking, and waterfront seating. Pavilion Shore Park is the former home of the Walled Lake Amusement Park and the Walled Lake Casino. On June 30, 2016, the roof was installed on the new restroom/shelter at Pavilion Shore Park. (Courtesy of Grace McCauley.)

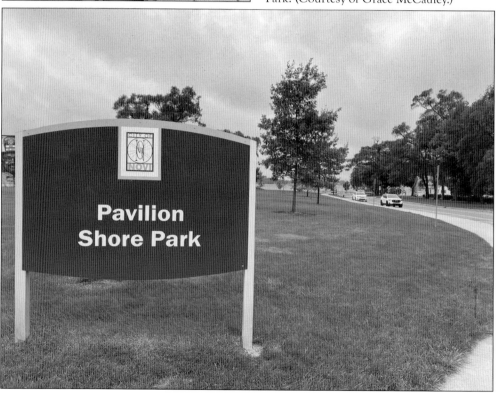

Six

EASTWOOD PARK

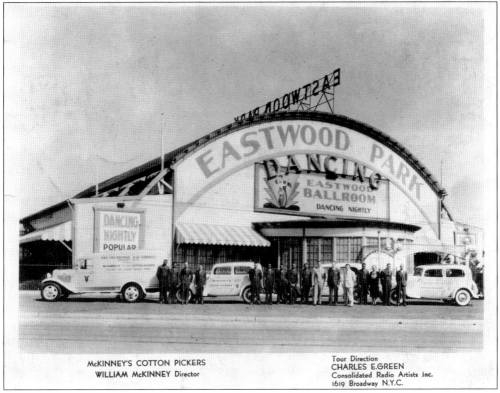

McKINNEY'S COTTON PICKERS
WILLIAM McKINNEY Director

Tour Direction
CHARLES E. GREEN
Consolidated Radio Artists Inc.
1619 Broadway N.Y.C.

Eastwood Amusement Park and Ballroom opened on April 27, 1927, at the northeast corner of Eight Mile Road and Gratiot Avenue in the then-semirural town of East Detroit (now Eastpointe). The 14-acre park on the outskirts of Detroit was once home to greyhound races. Eastwood offered a variety of fun activities ranging from a miniature golf course to a penny-nickel arcade, an Olympic-size swimming pool, a roller-skating rink, a ballroom for floor dancing and big bands, a freak show, an airplane swing, the Bobs roller coaster, a merry-go-round, the Tumble Bug, a giant rifle range with 600 moving targets, and picnic grounds. Shortly after opening, the ballroom was enlarged to accommodate overflow crowds and promised to be one of the largest ballrooms in the world. Local bands like William McKinney's Cotton Pickers and national stars like Tommy Dorsey, Duke Ellington, and Glenn Miller kept the customers coming in, along with "crowd-pleasing" events such as marathon dance contests during the Depression. (Courtesy of Detroit Public Library.)

The Haunted Shack, where water ran uphill, chairs balanced precariously on walls, and bad jokes abounded, first appeared at Eastwood Park in 1931. For an example of the humor one was subjected to, a barrel in the waiting area warned visitors of its dangerous "Baby Rattlers." It was filled with very small rattles. The shack had gravity-defying mysteries and intricate dark passageways as well as terrifying creatures guarding the entranceway. (Courtesy of Arcadia Publishing.)

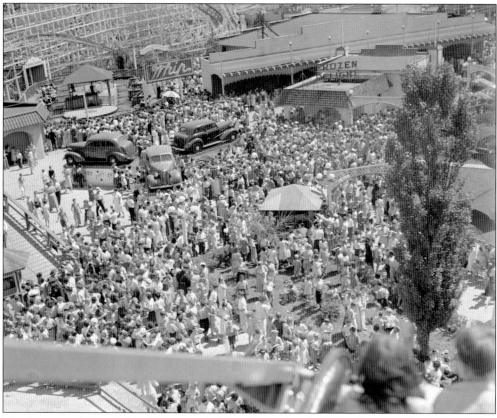

The first annual Detroit Mardi Gras was held on September 5, 1929, at Eastwood Park. Loud brass bands and beautiful costumes plus colorful flags, streamers, and pendants were featured for 10 days and nights until September 15. All people who showed up in costume were admitted to the park for free. A grand costume parade took place on the boardwalk every night at 10:00 p.m., and later, a spectacular fireworks display closed the evening's activities. (Courtesy of Virtual Motor City Collection, Wayne State University.)

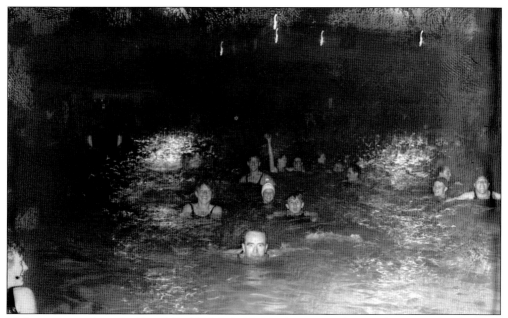

William Francis Murphy (April 13, 1890–July 19, 1949) was an politician, lawyer, and judge from Michigan. Frank Murphy took time out from his duties as mayor of Detroit (1930–1933) to take a dip at the Eastwood Park swimming pool. He was named to the Supreme Court of the United States in 1940. The Frank Murphy Hall of Justice in downtown Detroit is named after him. (Courtesy of Virtual Motor City Collection, Wayne State University.)

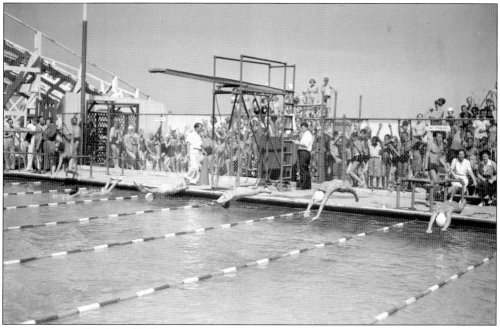

One of Eastwood Park's added attractions in the spring of 1930 was the new Olympic-size swimming pool that could accommodate 5,000 people a day. Designer and manager of swimming pools Capt. J.H. Seymor was brought in from the Venetian and Deauville Casino Pools in Miami, Florida, to manage the pool. (Courtesy of Virtual Motor City Collection, Wayne State University.)

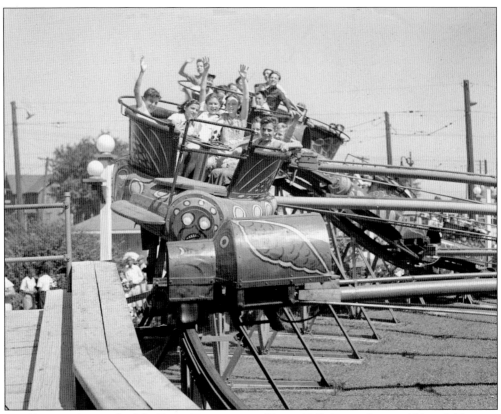

Tumble Bug rides were built by Traver Engineering of Beaver Falls, Pennsylvania. Although Traver is often given credit for the ride's design, it was actually designed by Hyla Maynes, who also invented the Caterpillar. Traver Engineering produced the Tumble Bug into the early 1930s, when the factory was taken over by one of Traver's employees and began operating under the name R.E. Chambers. Children wave with glee as they whirl around the Eastwood Park ride. (Courtesy of Virtual Motor City Collection, Wayne State University.)

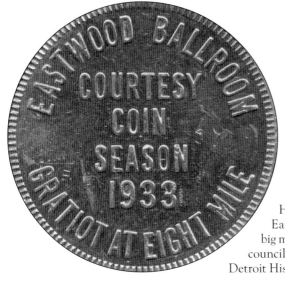

This is a token coin from Eastwood Ballroom that was made of aluminum with raised text. The reverse side reads, "Always Carry Coin—Save Money," and "This Coin Good for Low Prices Every Night. It Has the Same Value as All Special Tickets. Eastwood Ballroom." The ballroom was the big moneymaker at Eastwood Park until the city council revoked its license in 1948. (Courtesy of Detroit Historical Society.)

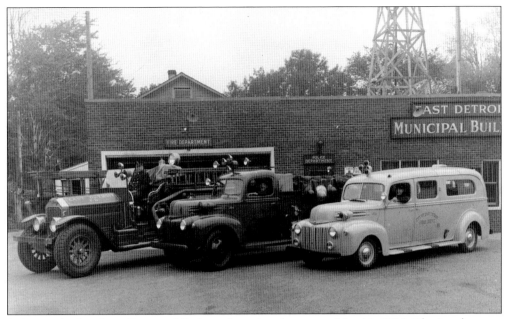

A fire in the Jungle at Eastwood Park made national news on May 16, 1936. The Jungle was a narrow maze lined with long, dry grass and mechanical animals with lighted eyes. Management claimed to have tested the grass and said that it was not flammable, but that night, it went up in flames. It was considered a miracle that only three people died, but many were burned. Two fire trucks and an East Detroit ambulance are shown here. (Courtesy of Detroit Historical Society.)

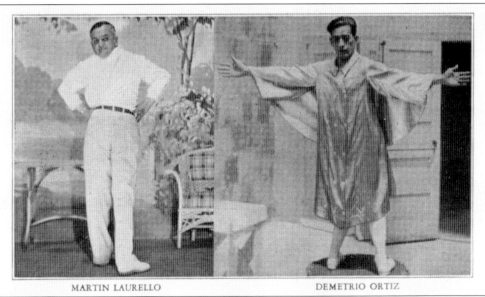

MARTIN LAURELLO DEMETRIO ORTIZ

Harry Lewiston (April 2, 1900–June 1, 1965; legal name Israel Harry Jaffe) was an American showman, freak show director, and barker. He wrote his memoirs under his stage name, published posthumously in 1968 as *Freak Show Man*. In 1950, Lewiston ran sideshows at Edgewater Park, Eastwood Park, and Jefferson Beach in Detroit, the first time that any single show operator had attractions at all three parks at once. Lewiston's Famous Freaks featured Martin Laurello at Eastwood Park. Laurello was billed as "the only man in the world who can turn his head completely around."

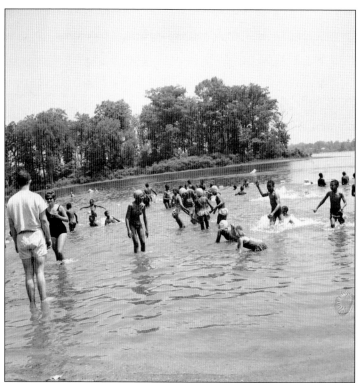

The Detroit Free Press Fresh Air Camp operated from the 1920s to the 1950s. For many years, the family of Merrill Mills gave the *Detroit Free Press* a restricted deed to the property. Around 1906, Mills donated this property for use as the Fresh Air Camp. The newspaper developed the property as a summer campground for underprivileged children. Eastwood Park hosted a charity event in 1933 that included 100 vaudeville, circus, radio, and musical acts over July 19 and 20. (Courtesy of Greater West Bloomfield Historical Society.)

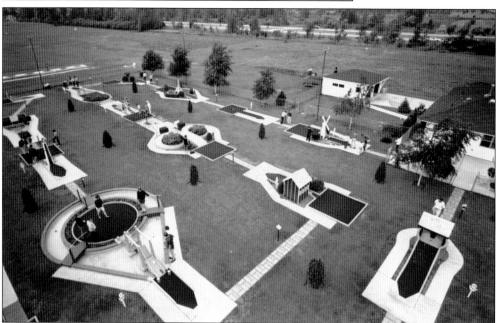

Garnet Carter was the first to patent what he called "Tom Thumb Golf" in the late 1920s. The game was described as a "whimsical version of golf" on a much smaller scale. Carter's vision was not simply putting greens—his idea added obstacles and required a geometric skill that had not previously existed. The course at Eastwood Park was only 120 feet long and 40 feet wide. (Courtesy of Virtual Motor City Collection, Wayne State University.)

The first calliope was a steam-powered instrument played with a keyboard. It was invented by Joshua Stoddard and demonstrated by his young daughter on July 4, 1855, in Worchester, Massachusetts. The firm he started went on to produce both hand-played and automatic steam calliopes used on large riverboats. Nellie Taylor, who played the first steam calliope built for Sun Brothers Circus, brought her novelty act in 1945 to Eastwood Park's Palace of Wonders.

The Bobs was a wooden roller coaster that reached speeds of up to 50 miles per hour (80 kilometers per hour). Making its debut in 1924, this terrifying wooden roller coaster was only 85 feet tall and may not have seemed initially impressive, but the steeply banked turns, abrupt drops, and wicked angles of the ride quickly gave it a thrilling reputation. (Courtesy of Britney Fields, Mount Clemens Public Library.)

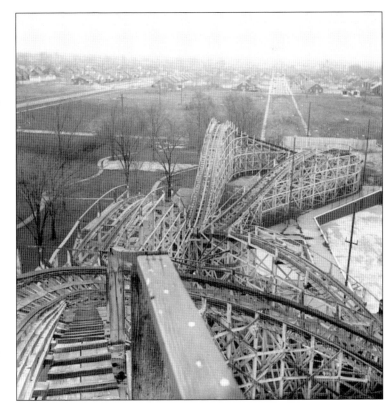

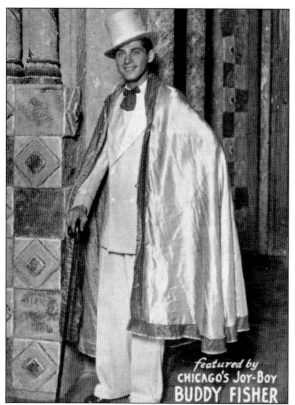

Locally born Buddy Fisher brought his orchestra to Eastwood Ballroom for an engagement and stint on WJR radio in 1928. Fisher was known as "Chicago's Joy Boy" for being master of ceremonies and orchestra leader at several Chicago ballrooms and theaters. His flashy attire (think Liberace) and ability to play a dozen instruments plus sing and dance (like Wayne Newton) made him a sensation.

featured by
CHICAGO'S JOY-BOY
BUDDY FISHER

The ornate Eastwood Park entrance frames a circle swing in the background. Built in 1926 for $300,000, the popularity of the ballroom forced the owners to add an addition almost immediately as they promised enthusiastic crowds "the largest amusement park ballroom in the world" in a *Detroit Free Press* ad. (Courtesy of Suzanne Pixley, East Detroit Historical Society.)

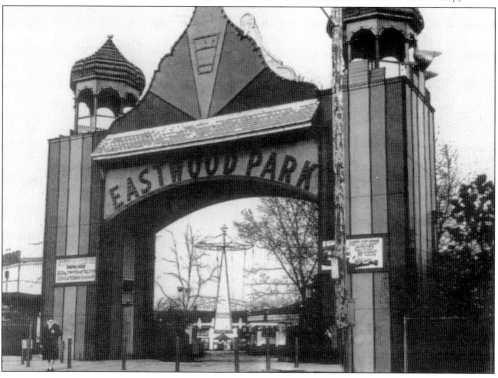

A park employee inspects a roller coaster inch by inch, looking for loose bolts, broken rail tracks, and cracks in the wood. Believe it or not, rain helped keep the bolts tight and the wood from cracking. An interurban bus is parked close to the entrance. Houses fill in parcels across the street in an example of suburban spread. (Courtesy of Britney Fields, Mount Clemens Public Library.)

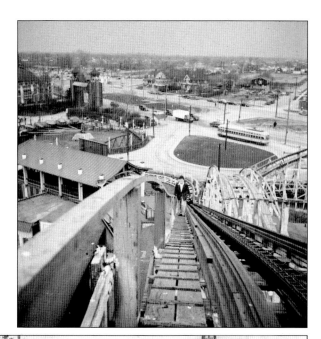

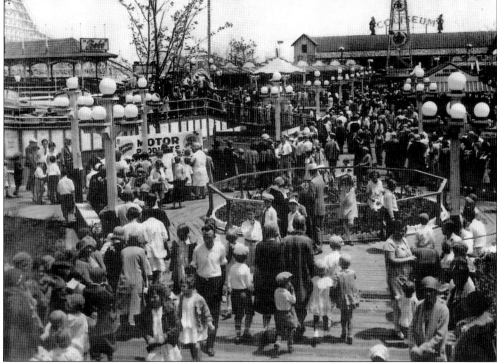

People crowd around the Eastwood Park Midway in the early 1930s. The park drew large throngs of people because of its location on two main arteries of traffic and a section of working-class families who were living in the area. Many local labor and church groups had picnics there. The president of the Eastwood Amusement Company, Henry Wagner, noted, "We are here to provide clean, safe, wholesome outdoor recreation for everybody." (Courtesy of Suzanne Pixley, East Detroit Historical Society.)

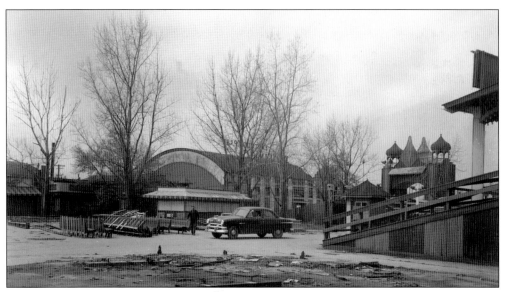

Eastwood Ballroom was decorated to look like an Italian garden with a wooden dance floor that measured 100 by 120 feet. People came from miles around to dance to big-name bands and attend marathon dances (early in its lifespan). As owners were fighting to keep their operating license in 1948, they spared no expense in bringing in top talent. (Courtesy of Suzanne Pixley, East Detroit Historical Society.)

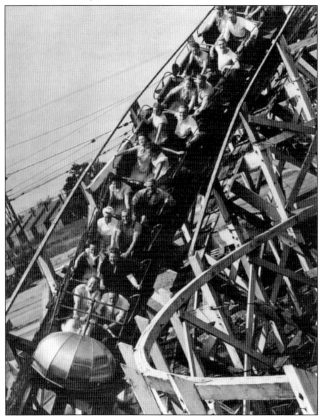

The Eastwood roller coaster was originally located at Electric Park until it closed. It was then taken apart and moved to the East Detroit location. The ride's first hill provided many thrills to passengers as they hurtled down the 100-foot drop. The yelling and screaming from this ride annoyed many of the new residents who had moved in around the park. (Courtesy of Suzanne Pixley East Detroit Historical Society.)

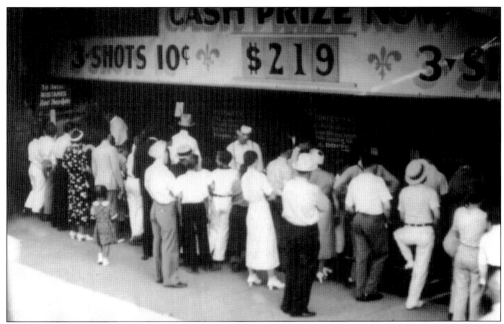

Along the midway, Eastwood Park featured a gigantic rifle range with over 600 moving targets. It was one of the largest shooting galleries in the world. In the late 1940s, East Detroit officials refused the park its operating license because games of chance offered odds where no one ever won. The legal fight took five years; there were several police raids, and the parties argued their case in public in countless news articles as well as in the courts. (Courtesy Suzanne Pixley, East Detroit Historical Society.)

Eastwood Park owners appealed all the way to the Michigan Supreme Court to no avail. Although the ballroom, skating rink (which accommodated 2,000 skaters), and swimming pool operated for a few more years, the lifeblood of the park was gone. By the early 1950s, Eastwood—including, most noticeably, its amusements—was dismantled. (Courtesy of Britney Fields, Mount Clemens Public Library.)

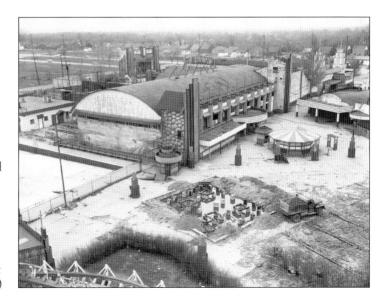

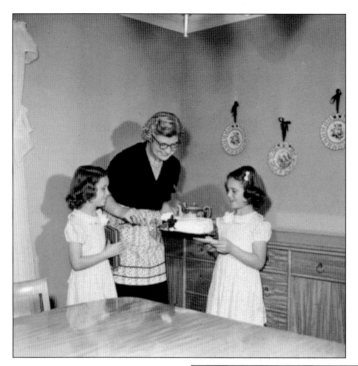

Mildred Stark shares a cake with twin daughters Kathy and Nancy. Before becoming mayor of East Detroit, Stark was a purchasing agent for a Detroit firm and president of a parent-teacher association. She became the leader of the anti-Eastwood committee and fought to close Eastwood Park for years. Stark joined a fractured council that split over whether to renew Eastwood Park's operating license in 1948. (Courtesy of Virtual Motor City Collection, Wayne State University.)

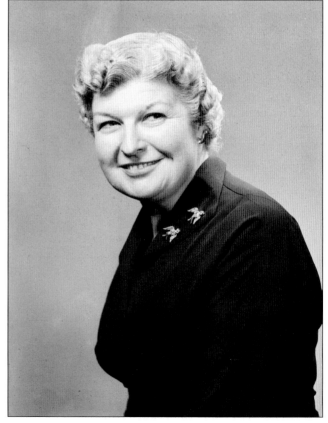

Mildred Stark became the first female mayor in Michigan when she was appointed in 1948 to lead the city of East Detroit, now known as Eastpointe. Objections about gambling, rowdy behavior, and neighbors' noise complaints caused the park to lose its license to continue operations. Its owners appealed all the way to the Michigan Supreme Court to no avail. By early 1952, Eastwood Park—including its amusements—was dismantled. (Courtesy of Virtual Motor City Collection, Wayne State University.)

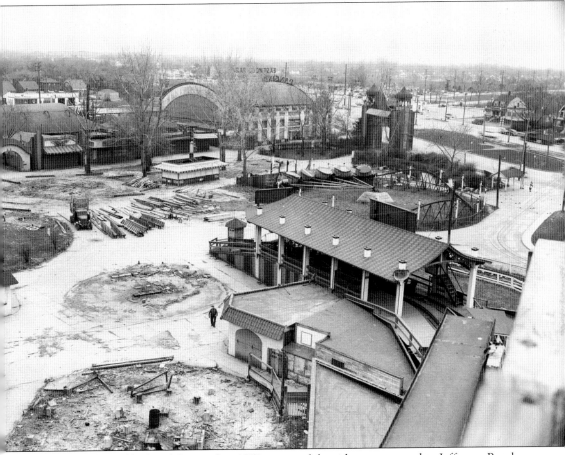

When the park finally closed for good in 1952, many of the rides were moved to Jefferson Beach Amusement Park in St. Clair Shores. The merry-go-round was sold to Cuba, and the antique steam-powered calliope was bought by Detroit Edison. The park had survived the Depression and World War II but was undone by changing demographics. (Courtesy of Suzanne Pixley, East Detroit Historical Society.)

Henry Wagner operated the "dime a dance" in the evenings at the Pier Ball Room at Electric Park. When Electric Park closed in 1927, Wagner started his first amusement park, Eastwood, with a partner, Max B. Kerner. After Henry's death in 1952, the Wagner sons continued to operate Walled Lake and Edgewater Parks. Son Alvin Wagner is shown here at the St. Clair Shores Jockey Club on his houseboat. (Courtesy *Detroit Free Press*/Zuma Press.)

In the late 1940s, Eastwood city officials asked park owners permission for children to swim in their 150-by-100-foot pool for a small fee. The owners refused until they lost their operating license. At that point, they offered the use of the pool in exchange for the license. The city refused, and the 800,000-gallon pool was torn down. (Courtesy of Virtual Motor City Collection, Wayne State University.)

Seven

EDGEWATER PARK

Edgewater Park, a 23-acre amusement park at Seven Mile and Berg Roads near Grand River Avenue on Detroit's West Side, opened on July 2, 1927. It quickly became one of Detroit's most popular recreation spots, especially during the Great Depression and World War II, when it provided a cheap way to have fun. In 1947, the park was purchased by Henry Wagner, a former employee of Detroit's Electric Park. Edgewater was his third park, after Eastwood and Jefferson Beach. That same year he increased the number of Edgewater's rides from seven to 23. The park featured popular attractions such as the wooden roller coaster Wild Beast, a gigantic 110-foot Ferris wheel, and the Hall of Mirrors. After Henry's death in 1952, the Wagner sons (Alvin, Cyril, and Milton) continued to invest in Edgewater Park as they closed the other parks. A concert was included in the weekend ticket price and featured Motown artists among others, which made the park a popular spot with teenagers. Eventually, the park could not compete with the larger amusement parks like Bob-Lo and Cedar Point with their more numerous and expensive rides. It closed on September 13, 1981.

Edgewater Park's Tilt-a-Whirl and the Ferris wheel (seen in the background) were two of the most popular rides. The Tilt-A-Whirl consists of seven freely spinning cars that hold three or four riders each and are attached at fixed pivot points on a rotating platform. As the platform rotates, parts of the platform are raised and lowered, with the resulting centrifugal and gravitational forces on the revolving cars causing them to spin in different directions and at variable speeds.

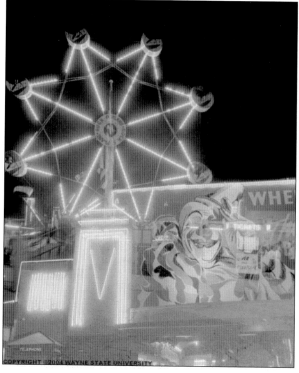

The Rock-O-Plane is an amusement park ride designed by Lee Eyerly in 1948 and manufactured by the Eyerly Aircraft Company of Salem, Oregon. Sometimes nicknamed "The Cages" or "The Eggs," its shape is similar to that of a Ferris wheel, but the seats are enclosed and rock and roll as the ride turns. Edgewater's Rock-O-Plane is lit up at night and looks spectacular. (Courtesy of Virtual Motor City Collection, Wayne State University.)

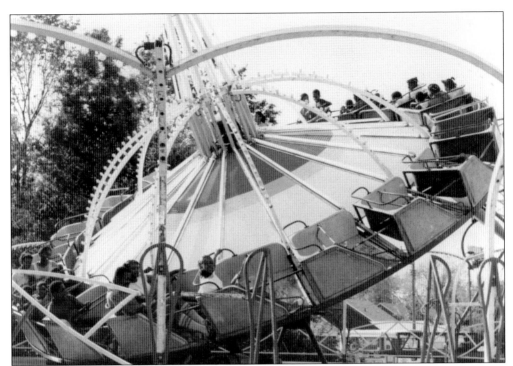

Carl Sedlmayr of Royal American Shows discovered the Trabant (German for satellite) in Germany. He purchased the manufacturing rights from the young German man who invented it and approached Harold Chance of Chance Industries to build the ride. Chance saw the potential in the ride, made it flashier by adding lights and colorful panels, and mounted it on a trailer so it would be portable.

Bumper cars or dodgems are the generic names for a type of flat amusement ride consisting of multiple small electrically powered cars that draw power from the floor and/or ceiling and are turned on and off remotely by an operator. During their heyday from the late 1920s through the 1950s, the "Rolls Royce" of bumper cars was the Lusse.

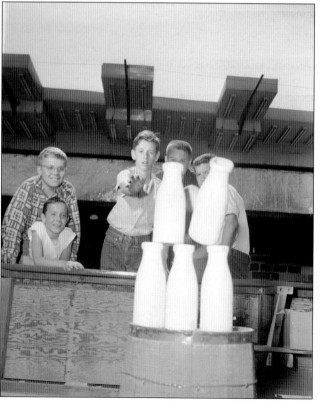

Ring toss is a game where rings are tossed around a peg. It is a common sight at amusement parks. A variant seen here, sometimes referred to as "ring-a-bottle," replaced pegs with bottles, where the thrower may keep the bottle (and its contents) if successful. Two women and their kids try their luck with 12 chances for a $1.

Boys line up to play a milk bottle carnival game in the early 20th century. Five solid wood milk bottle–shaped pins were lined up or stacked and two wooden balls knocked the pins down. Some operators added weights to bottles to make it hard to knock them completely over. (Courtesy of Virtual Motor City Collection, Wayne State University.)

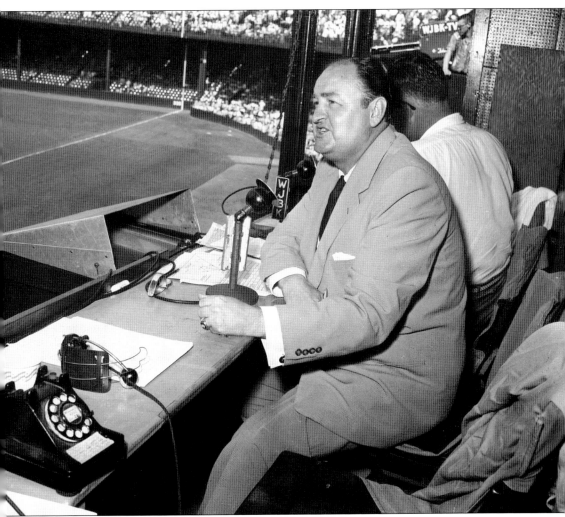

Al Kaline and Van Patrick made a personal appearance at Edgewater Park on Friday, August 26, 1955. Kaline was in the process of becoming the youngest player, at 20, ever to win the American League (AL) batting title. Van Patrick called Detroit Lions games from 1950 until his death in 1974. Patrick (shown here in the broadcast booth at Briggs Stadium) also owned four radio stations. (Courtesy of Virtual Motor City Collection, Wayne State University.)

The Paratrooper, also known as the "parachute ride" or "umbrella ride," is a type of amusement park ride. The seats are free to rock sideways and swing out under centrifugal force as the wheel rotates. In contrast to modern thrill rides, the Paratrooper is a ride suitable for almost all ages.

Children are enjoying the airplane ride at Edgewater Park. This was the closest many of these city kids would get to flying in a real plane. The blurry photograph also gives one an idea of the speed these kids experienced. This ride presented a stunning view at night with its brilliant lighting and scary appearance. (Courtesy of Virtual Motor City Collection, Wayne State University.)

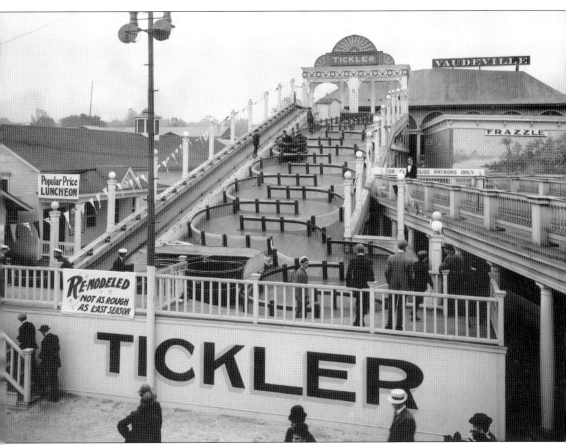

The Tickler ride at Chester Park in Cincinnati, Ohio, was first installed in 1908. The cars in the ride rolled and bounced, drawn downward by gravity, not unlike the ball in a pinball machine. This ride was a favorite during the 1930s at Detroit's Edgewater Amusement Park. The Tickler was a thrilling amusement attraction for families and friends.

The Edgewater Ferris wheel, lit up by neon lights in 1955, presented a spectacular sight at night. Edgewater Park opened in 1927 with seven rides. By 1947, the park had 23 rides jammed onto a tiny 22 acres. An airplane ride, dodgem cars, the Whip, Tilt-A-Whirl, and Hall of Mirrors were among the favorite attractions. (Courtesy of Virtual Motor City Collection, Wayne State University.)

For those who did not pack a lunch (or forgot to), Edgewater had plenty of food choices, including the tasty ribs slathered in barbecue sauce and baked beans. Other items featured funnel cakes, elephant ears, hot dogs, cheese on a stick, soft pretzels, churros, french fries, corn dogs, and ice cream along with soda pop and beer.

The Zipper is an amusement ride invented by Joseph Brown under Chance Rides in 1968. Though a staple of amusement parks and carnivals, the original models of the Zipper garnered a reputation for being unsafe due to their rough nature, and a series of deaths on the rides in the late 1970s after cabin doors came unlatched led to a series of revisions, primarily the restructuring of the door lock system. (Courtesy of *Detroit Free Press*/ZUMA Press.)

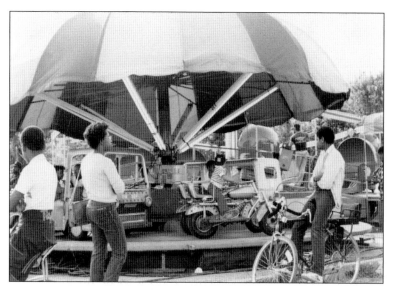

This classic Hampton Co. umbrella-top ride offers a variety of fire trucks and motorcycles for the kids to choose from. The Combo Kiddie Ride is a tame ride for children. It features a combination of motorcycles, sports cars, and a fire truck. It is a simple ride that spins in a continuous circle.

At amusement parks, the carnival games are usually owned and operated by the park owner. Carnival games are usually operated on a "pay per play" basis. Most games offer a small prize to the winner. Prizes may include items like stuffed animals, toys, or posters. Boys in 1980 are shown here tossing softballs in the hope of winning a big plush doggie. (Courtesy of *Detroit Free Press*/Zuma Press.)

In 1966, comic book hero Batman became the hottest TV show with relatively unknown actor Adam West becoming an overnight sensation. Dressed as the caped crusader, West pocketed $20,000 for three shows on April 16 at Edgewater Park. West arrived at Edgewater in a hard-top Lincoln Continental—park officials found convertibles too dangerous after *The Man From U.N.C.L.E.* star David McCallum was mobbed by teenage girls the year before. West was outfitted with his bat cape, bat cowl, and other bat gadgets. (Courtesy of Virtual Motor City Collection, Wayne State University.)

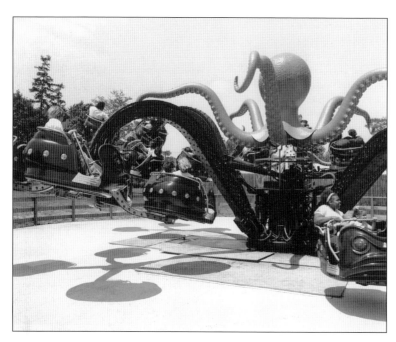

The Octopus is a type of amusement ride in the shape of an octopus. Five to eight arms attached to a central axis of rotation move up and down in a wavelike motion. The Wagner brothers paid $100,000 for it in 1951 and noted that it was "more than we paid for the entire park." (Courtesy of *Detroit Free Press/ Zuma Press.*)

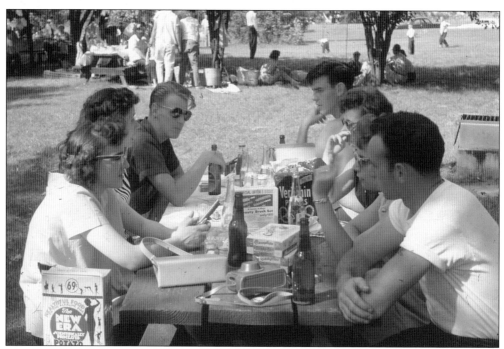

During the 1970s, the Wagner brothers kept Edgewater Park solvent by renting it out to groups for a day or weekend. In 1939, Campfire Marshmallows were part of marshmallow history when Mildred Day and Malitta Jensen of the Campfire Girls used Campfire Marshmallows to create the first Rice Krispies marshmallow treat as part of a fundraiser for the Michigan Campfire Girls Council.

One of the top attractions at Edgewater Park was the Beast roller coaster. This roller coaster could reach speeds of 96 miles per mile on certain areas of the track. The Beast track lap was one mile in length, and its cars could travel it in one minute and fifteen seconds (or 58 miles per hour). (Courtesy of *Detroit Free Press*/Zuma Press.)

Some kids laugh and others cry as they whip around the Edgewater Park coaster for kids. The Herschell Little Dipper was designed by David Bradley, who installed the prototype at his Beverly Park in 1946. Bradley advertised the ride for the 1947 season, and rights to the ride were sold to Allan Herschell near the end of 1948. (Courtesy of Virtual Motor City Collection, Wayne State University.)

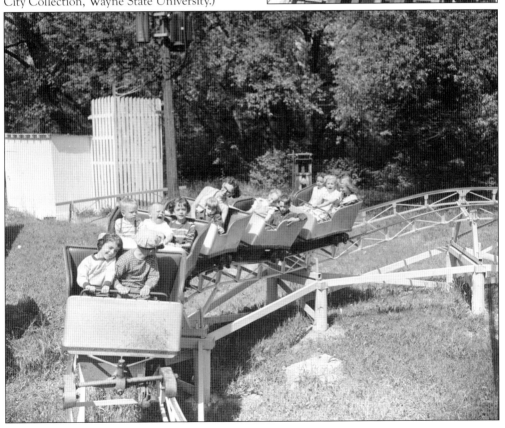

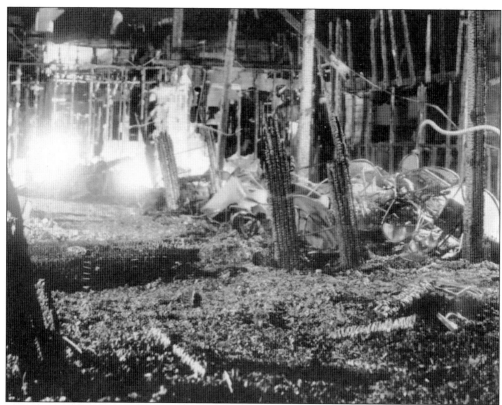

On October 3, 1954, a bolt of lightning ignited a fire at the Edgewater Park Ballroom, where 400-plus dancers escaped although two other people died. One band member, Bruno Jaworski, perished trying to save his $140 trombone. The ballroom was built in 1927 and could accommodate 2,000 dancers at one time. Detroit's top 24 musical groups held a benefit from 9:00 p.m. to 3:00 a.m. for Jaworski's widow and six children on Monday, November 1, at the Graystone Ballroom and raised $4,000. Over 2,500 attended the benefit, and they paid $1.50 each.

The Roundup made its debut in 1954 and was manufactured by Frank Hrubetz, USA. Two boys hang on for dear life as they whiz along Edgewater's Roundup ride in 1969. This spinning ride lifts off the ground at a 45-degree angle as the floor opens from the bottom. The Roundup remains popular with an appeal that has lasted through generations of amusement parkgoers.

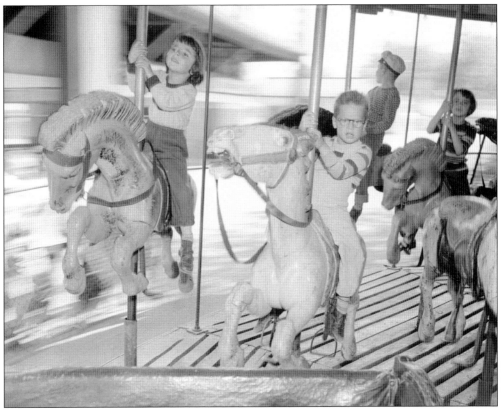

The G.A. Dentzel Company was an American builder of carousels in Philadelphia in the late 19th and early 20th centuries. This little girl holds on for dear life at Edgewater as she whirls around up and down on her flashy horsey ride. Its founder, Gustav Dentzel, immigrated to the United States in 1860 from Germany. (Courtesy of Virtual Motor City Collection, Wayne State University.)

The city of Detroit and the park's demographics changed dramatically in the 1970s when predominately white park patrons were replaced with more black families. While the park survived for a while with groups renting out the facilities on certain days and weekends, it got a reputation for troublemakers. Attendance dropped steadily as the decade came to an end. (Courtesy of Virtual Motor City Collection, Wayne State University.)

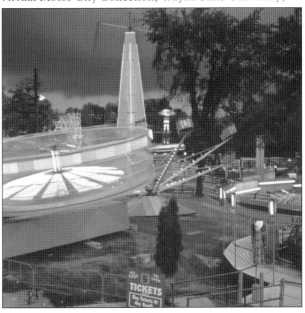

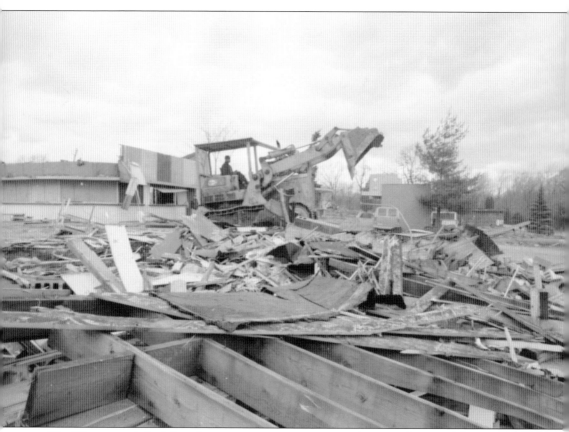

The Wagners switched from hiring itinerant carny-type workers to taking on "about a hundred Detroit kids, because our customers came from Detroit, and we were a Detroit institution." However, Edgewater soon became an eyesore and was called a public nuisance as the grass went uncut, rides became rusty, and vandals became more prevalent. The giant Ferris wheel was sold off when it broke down in 1978. The Wagners held an auction in 1981 and sold off whatever they could. The Norton of Michigan Auction was held on September 26, 1981, with the entire amusement park to be sold piece by piece. (Courtesy of Virtual Motor City Collection, Wayne State University.)

Eight

BOB-LO AMUSEMENT PARK

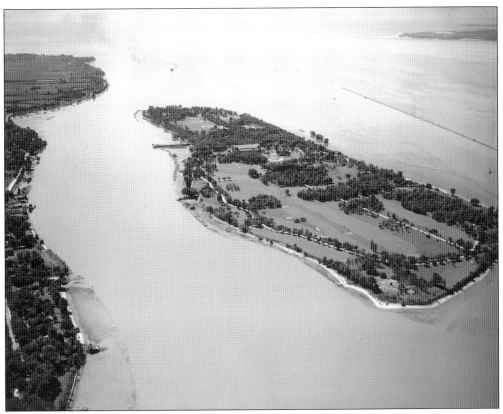

Located 20 miles south of Detroit where the Detroit River meets Lake Erie, Bob-Lo Island was the ultimate summer playground for families from Detroit and Windsor for nearly 100 years. In its prime, the island housed an amusement park with one of the world's largest dance halls, an elegant restaurant, and a hand-carved carousel. It also employed two large Frank Kirby–designed ferry steamers—complete with dancing and other entertainment—to transport patrons to and from the island, which was not accessible by car. Bob-Lo was unique from its discovery by French explorers to its subsequent use by missionaries, British military men, escaped slaves, farmers, and finally, the wealthy class, who developed the island as a summer resort. It was not until the Detroit, Belle Isle, and Windsor Ferry Company, looking to expand its business ventures, bought the island in 1898 that Bob-Lo became known as a destination for Detroit's growing middle class. The park provided the perfect place for Detroiters to dance and play and simply escape the whirlwind of what was rapidly becoming an industrial and mechanized city. (Courtesy of Virtual Motor City Collection, Wayne State University.)

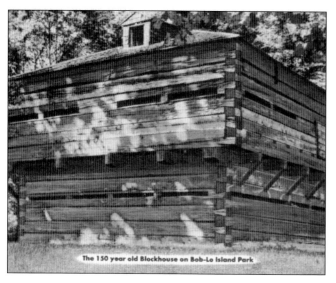

The 150 year old Blockhouse on Bob-Lo Island Park

Bob-Lo Island was originally called Bois Blanc by the French because it was covered by birch and beech trees along its 272 acres. French Catholic priests set up a mission for 70 Huron Indian families in the 1700s. Shaunee Indian chief Tecumseh made the island his headquarters during the War of 1812. Three blockhouses were built on the island in the 1830s, and they became stop-offs for runaway slaves fleeing the South during the American Civil War. (Courtesy of Southwestern Ontario Digital Archive.)

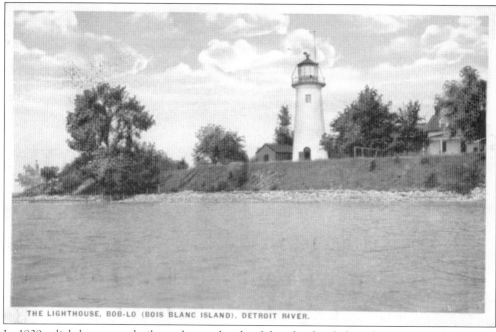

THE LIGHTHOUSE, BOB-LO (BOIS BLANC ISLAND), DETROIT RIVER.

In 1839, a lighthouse was built on the south side of the island to help sailors navigate the narrow straits behind it. During the 1850s, Col. Arthur Rankin bought 223 acres of the island for $40 from the Canadian government. The 1890s saw the island sold to the Detroit, Belle Isle, and Windsor Ferry Company, and the Bob-Lo Excursion Company was created in 1898. (Courtesy of Southwestern Ontario Digital Archive.)

The ferry *Promise* was the first to shuttle passengers to and from Bob-Lo Island. This proved inadequate, so Frank Kirby built the steamship *Columbia* in 1902 and named it after Christopher Columbus. Its first trip to Bob-Lo was on July 8, 1902. The *Ste. Clair*, named after Lake St. Clair and the St. Clair River, launched on May 10, 1910, and made its maiden voyage later that year. (Courtesy of Virtual Motor City Collection, Wayne State University.)

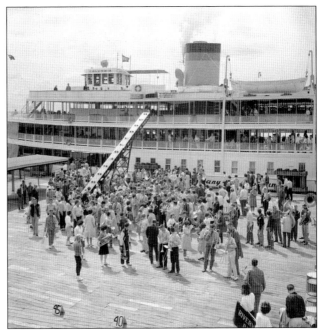

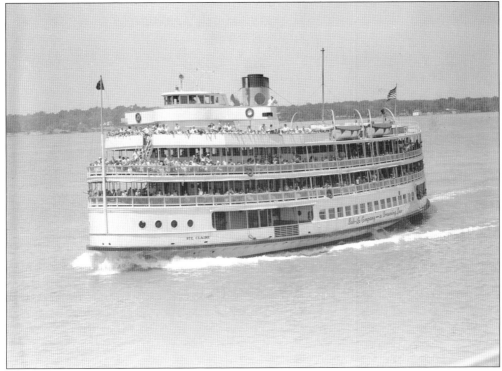

The *Ste. Clair* was 197 feet long, 65 feet wide, and 14 feet deep. The engine was a triple expansion steamer with 1,083 horsepower. The *Ste. Clair* and its sister boat *Columbia* operated for 81 years on a single run, which is an unequaled record in US maritime history. The 20-mile ride from downtown Detroit dock to Bob-Lo Island took an hour to 80 minutes. (Courtesy of Virtual Motor City Collection, Wayne State University.)

In 1901, electricity was installed on the island at the same time new picnic grounds were laid out, child-friendly and enjoyable by adults as well. Bob-Lo's most notable and well-loved acquisition occurred in 1906. Built in 1878 at Coney Island, New York, the Mangels-Illions carousel and pipe organ were installed and became island fixtures for the next 83 years.

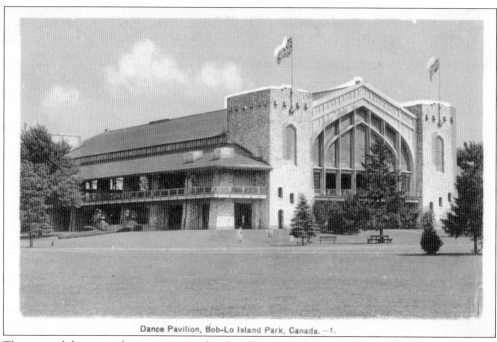

Dance Pavilion, Bob-Lo Island Park, Canada. —1.

The original dance pavilion was so popular that a larger one was constructed in 1913, billed as the largest pavilion of its kind in North America. Henry Ford financed a dance hall that was designed by John Scott. The dance hall held 5,000 dancers at full capacity and featured one of the world's largest orchestrions from the Welte Company: a 16-foot-tall, 14-foot-wide, self-playing Wotan model with 419 pipes and a percussion section. (Courtesy of Southwestern Ontario Digital Archive.)

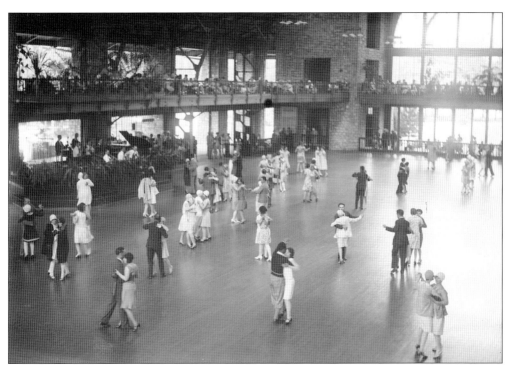

There were certain restrictions in the pavilion for the dancers. The activities were conducted by Capt. William A. Campbell, who ruled that only three dance styles were permitted: the two-step, the waltz, and the foxtrot. This would not stop some people from causing a scene during the middle of an ensemble, as illustrated by this 1906 *Detroit Free Press* account: "Last year [1905], Samuel Meisner was put off the *Columbia*. His friend Nederlander was removed from the dancing floor for indulging in an obscene dance [the rag]." (Courtesy of Virtual Motor City Collection, Wayne State University.)

During the 1920s and 1930s, swimming contests were held that went from Belle Isle to Bob-Lo, covering 24 miles. The best time was 8 hours and 42 minutes, turned in by 17-year-old Dorothy de Caussin and 15-year-old Ida Mutnick, both of Detroit. Dorothy de Caussin had never attempted to swim more than 4 miles before. Although she had been swimming for some time, de Caussin decided on this race "on the spur of the moment." (Courtesy of Virtual Motor City Collection, Wayne State University.)

Since 1849, the St. Andrew's Society of Detroit has been hosting the longest continuous Scottish Highland Games in North America. Bob-Lo Island hosted many of these Highland Games from the 1930s until the late 1980s. Bagpipers and modern dance bands from the United States and Canada played on the Bob-Lo boats and island in the late 1930s. (Courtesy of Virtual Motor City Collection, Wayne State University.)

These Scottish lasses, dressed in traditional costumes, are sitting in preparation for the dancing competition that included the Highland fling, sword dancing, and the *seann truibhas*. The caber toss was a 16th-century Highland tradition that required tremendous strength. Scotsmen in vivid kilts grabbed 20-foot telephone poles, balanced the poles on their shoulders, ran across a field, and heaved them end over end. (Courtesy of Virtual Motor City Collection, Wayne State University.)

On June 21, 1945, 24-year-old Sarah Elizabeth Ray boarded the Bob-Lo boat. She had just graduated from secretarial school, so she and her classmates decided to take a ride to Bob-Lo Island. She was the only African American with her group on the boat. Ray was asked to leave but later filed suit in a Detroit court. (Courtesy of Aaron Schillinger, the Sarah E. Ray Project.)

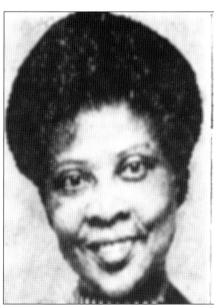

SUPREME COURT UPHOLDS MICHIGAN ANTI-DISCRIMINATION LAW

Mrs. Ray's Rights Violated, Justices Rule

Washington, Feb. 2 (AP)- The Supreme court ruled 7-2 today that a steamship company's refusal to transport a woman from Detroit to Bob-Lo Island, Ont., violated Michi-

The Bob-Lo Excursion Company was initially found guilty of violating the State Civil Rights Act and fined $25. The company appealed and the case ended up in the US Supreme Court. The court ruled in favor of Sarah Elizabeth Ray. The head of the legal team was the NAACP's chief legal counsel, Thurgood Marshall. (Courtesy of *Detroit Free Press*/Zuma Press.)

In 1931, future Detroit mayor Coleman Young, 15 years old, was part of a Boy Scout group but was stopped at the dock before boarding. Young was told by a Bob-Lo employee they did not allow Blacks. He later became the skipper of the city of Detroit and guided it through treacherous waters for 20 years from 1974 until 1994. Young is at the helm of the Windsor-Detroit Freedom Festival in front of Cobo Hall Convention Center. (Courtesy of *Detroit Free Press*/Zuma Press.)

When the Bob-Lo Excursion Company decided not to operate in 1949, it brought a howl of media coverage from angry residents. Windsor, Canada, mayor Arthur Reaume wanted the island to be named a national park, but Troy H. Browning from Grosse Pointe, Michigan, came to the rescue, purchasing the operation in 1949 and readying it for a June 1 opening. His actions earned him a citation from the Detroit City Council, grateful that the popular island would remain. (Courtesy of *Detroit Free Press*/Zuma Press.)

This classic Hampton umbrella-top ride offers a variety of fire trucks and cars for the kids to choose from. Children can drive smoothly around a circular track and honk the horn for some extra fun. A brother and sister enjoy taking the wheel of their own red fire truck. This ride could carry nine kids at a time. (Courtesy of Virtual Motor City Collection, Wayne State University.)

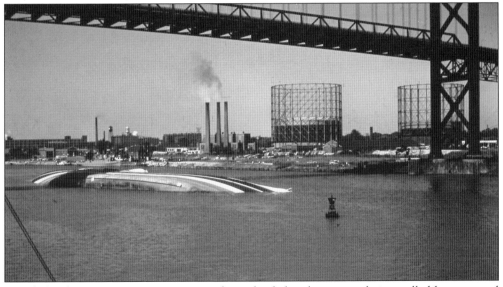

British freighter M.V. *Montrose* ran into a barge loaded with concrete being pulled by a tug and sank under the Ambassador Bridge on the night of July 30, 1962. All the crew got off safely, and the *Windsor Star* reported about 20,000 spectators in Windsor and Detroit watched "the lumbering ship flop to her side in 30 feet of water." It became such an attraction there were boat cruises to see it and an increase in passengers on the Bob-Lo Amusement Park boats. (Courtesy of John Martin Strauss.)

Captain Bob-Lo was introduced in 1955, played by the four-foot, four-inch Joe Short. He worked whatever schedule he wished when he greeted and entertained kids on the boat ride to and from Bob-Lo Island. Short wore an oversized Captain Bob-Lo hat, binoculars for navigating, a scepter, and a colorful uniform while he handed out coloring books. He also regaled children on the trip with various adventure tales and knock-knock jokes. (Courtesy of Burton Historical Collection, Detroit Public Library.)

Captain Bob-Lo handed out ice cream, plastic jewelry, and all kinds of goodies to the children on the round trip from Detroit to Bob-Lo Island. When he was admitted to the hospital in 1974, no mention was initially made of this. Once the hospital stay was reported, the hospital was mobbed with visitors and well-wishers. Joe Short passed away at the age of 90 on Christmas Eve 1974. (Courtesy of Burton Historical Collection, Detroit Public Library.)

Word of Life church groups had 3,000 members make the season's first run on a charter excursion to Bob-Lo Island in 1979. Grinning members from Akron, Ohio, (from left to right) Cathy Rosens (17 years old), Lisa Jarrard (16), Liz Biby (17), and Barbara Childers prepare to leave the dock on the *Columbia* from the Hart Plaza in downtown Detroit. (Courtesy of *Detroit Free Press/*Zuma Press.)

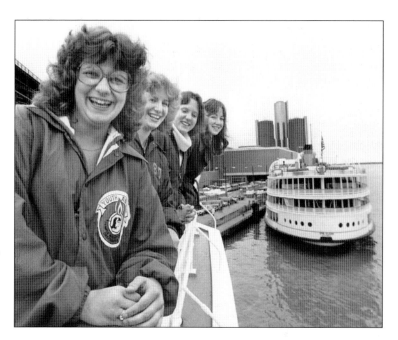

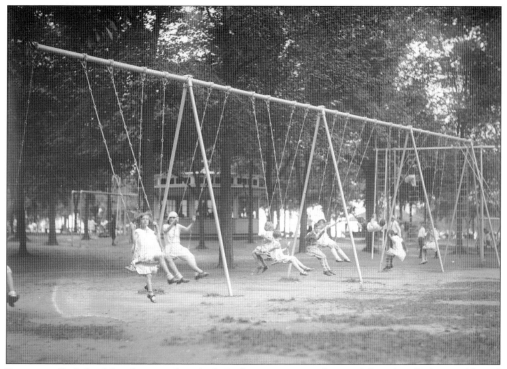

Picnics at Bob-Lo Island were a big deal. Park management boasted "we do all the work" and "discounts allowed on group outings of all sizes." It also assisted in planning, providing, and posters and flyers to promote and publicize outings. Game equipment, a large green picnic area, grandstands, shelters, restrooms, a public address system, swings, and horseshoe courts were also made available. (Courtesy of Virtual Motor City Collection, Wayne State University.)

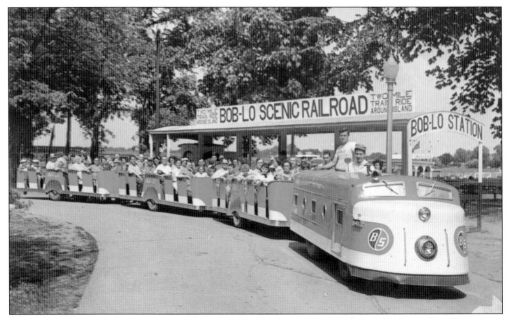

Bob-Lo's miniature railroad was perfect for those interested in something more easy-going than the island's roller coaster. The railroad began operating on the island in 1956. In the ride's final incarnation, the train was a scale recreation of Central Pacific Railroad's 19th-century *C.P. Huntington*. Bob-Lo's trains made a 20-minute circuit around about two miles of track around the island. (Courtesy of Southwestern Ontario Digital Collection.)

In 1985, Bob-Lo's Screamer was a steel coaster notable for its corkscrew segment. The ride kicked off with a 75-foot drop and reached speeds of 40 miles per hour. It was an exciting 16-passenger pendulum thrill ride that spun mounted atop an elevated tower, taking riders up to 60 feet in the air. The ride started swinging in both directions as it gained momentum.

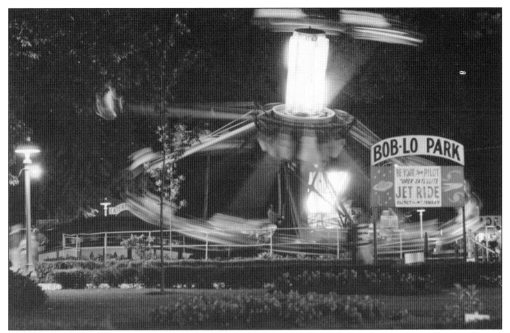

Bob-Lo originally used Traver Seaplane De Luxe cars, and the ride was known as the Aeroplanes. Later, the Super-Satellite Jet Ride was added in 1957. This attraction was manufactured in Germany by Kasper Klaus. Riders were able to raise and lower the sweep of their individual rocket using a control lever. (Courtesy of Virtual Motor City Collection, Wayne State University.)

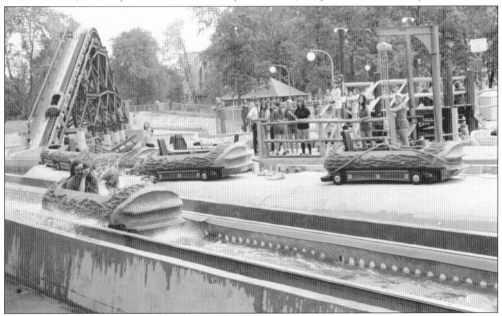

The Log Flume provided a great way to cool off on a hot summer day. This rustic-themed water ride traveled over a hilly course that included a 40-foot plunge into the water along its 1,200-foot ride. The ride was opened in 1972 and remained a favorite for the remainder of the park's seasons. One of the logs from the ride is part of the Detroit Historical Society's collection. (Courtesy of Virtual Motor City Collection, Wayne State University.)

One cannot tell if this Falling Star rider is excited or scared. The Falling Star was an exciting amusement ride consisting of a stationary horizontal gondola with a 360-degree swinging pendulum. According to 40-year-old Detroiter Roland Matthews, "I got a few more butterflies than any of the other thrill rides and, yeah, it was nice." (Courtesy of *Detroit Free Press*/Zuma Press.)

Kids could get their first driving experience in these classic touring cars and journey around a quarter-mile scenic track. This antique car ride is styled after the famous Model A cars of the early 1900s. They travel at a top speed of three miles per hour, with a maximum capacity of four adults per car. This teen from Livonia, Michigan, seems to be enjoying her slow but safe ride.

Behind every clean and safe amusement park is a solid maintenance plan. Proper maintenance management across rides or exhibits is important for visitor satisfaction and safety. Facilities managers at amusement parks can prevent breakdowns and extend asset life on amusement rides, animal cages, arcade games, landscape, roller coasters, and water rides. Bob, the park painter and roller coaster repairman, has scaled high into the sky to check rails, loose bolts, and more. (Courtesy of Virtual Motor City Collection, Wayne State University.)

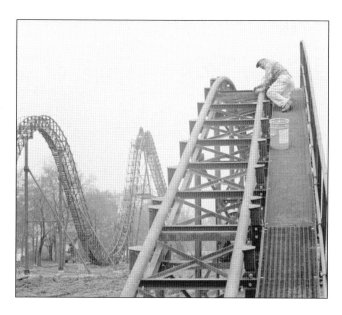

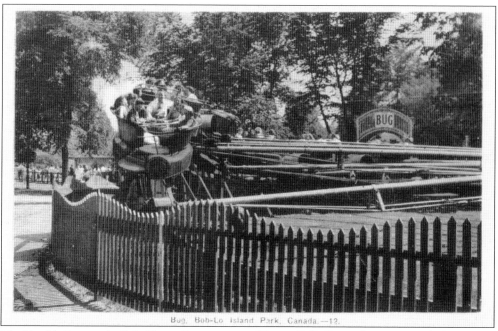

The Tumble Bug was built by Traver Engineering of Beaver Falls, Pennsylvania. Traver's factory was taken over in the early 1930s by one of his employees, Ralph E. Chambers. Children are all smiles and yells as they twirl around on this Bob-Lo ride. However, there was an accident on August 24, 1965, when a car fell off the track, killing one person and injuring eight passengers. (Courtesy of Southwestern Ontario Digital Collection.)

Bob-Lo Island was the premier vacation destination for residents in the Detroit Metro area, but for those who performed in the Meadow Brook Estate, Bob-Lo was a fond memory of performances that graced the stage of the Carousel Theater; the Carousel Building, erected in 1905, housed the first amusement ride on Bob-Lo Island and served as a convention hall and, later, the roller-skating rink (beginning with the 1940 season) before ending up as a theater. The in-house song and dance group Bob-Lo Islanders performed musical hits from many decades there. (Courtesy of *Detroit Free Press*/Zuma Press.)

The Aeroplane chair swing ride is an amusement ride that is a variation on the carousel in which the seats are suspended from the rotating top of the carousel. On some versions, particularly on the Wave Swingers, the rotating top of the carousel also tilts for additional variations of motion. These rides look like biplanes from long ago. (Courtesy of Virtual Motor City Collection, Wayne State University.)

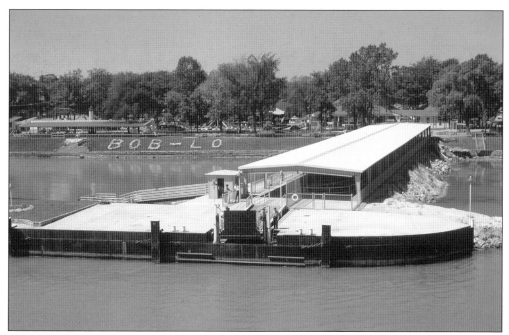

The early 1960s saw the ferry landing dock replaced by sinking a lake freighter (*Queenston*) and using its deck as the walkway. This decade had other major improvements with the establishment of the Safari Trail Zoo. In 1972, seven baboons escaped their cages and did a tour of the park. The last baboon escapee was caught after it was coaxed out of the funhouse. (Courtesy of John Martin Strauss.)

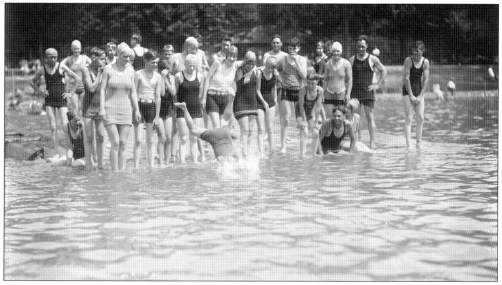

Bob-Lo Island was one of Detroit's favorite recreation grounds, situated in Canadian waters at the junction of the Detroit River and Lake Erie. It was a great place to go swimming in the 1920s, 1930s, and 1940s on the hot summer days before air-conditioning. The island was comprised of 225 acres and was equipped with a casino, dancing pavilion, bicycling, roller skating, an athletic field, a bathing beach, and similar conveniences. This photograph was taken before bikinis were invented. (Courtesy of Virtual Motor City Collection, Wayne State University.)

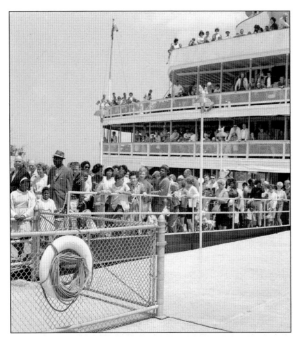

One thing that helped Bob-Lo in the first two decades of Browning ownership was the closure of more rival parks. Amusement park researcher Mike Schulte says, "By the 1940s, the second generation of area amusement parks were in trouble and facing NIMBY [Not In My Backyard] pressures. Eastwood was the first to close around 1949. While the aging amusement parks were failing, the Brownings likely saw the opportunity to breathe new life into Bob-Lo by creating a new, third-generation amusement park. Jefferson Beach would close in 1959. Farther inland, the Walled Lake Park was gone after 1968. Bob-Lo's last major competitor in Detroit, Edgewater Park, would throw in the towel in 1981." (Courtesy of Virtual Motor City Collection, Wayne State University.)

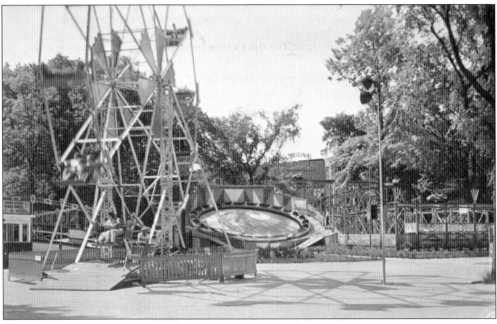

After owning Bob-Lo for 30 years plus surviving the 1967 Detroit riots and 1970s Gulf oil embargo, Todd Browning sold out to Cambridge Properties of Kentucky in 1979, and within two years, they declared bankruptcy and sold the park to AAA in 1983. AAA made improvements and updated the 109-year-old Mangels-Illions Carousel but sold the park within five years. Though it was not looking for a buyer, the Michigan AAA sold Bob-Lo Island for $20 million in 1988 to the International Broadcasting Corporation (IBC), a Minneapolis-based concern that owned the Harlem Globetrotters and Ice Capades. This photograph shows the Ferris wheel and Moon Rockets rides. (Courtesy of Southwestern Ontario Digital Archives.)

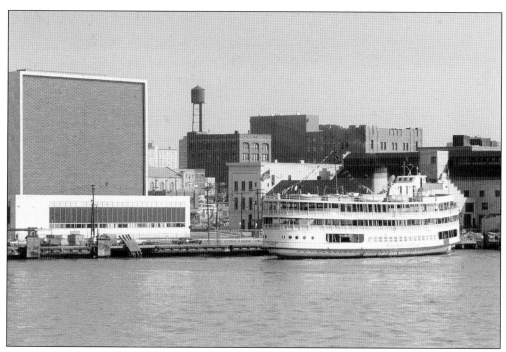

An event on Memorial Day 1988 occurred that spelled eventual doom for the park. Day-long package trips were sold to two Detroit public schools that had rival gangs. Once on the island, fistfights broke out. No arrests were made there, but the Detroit police were on call at the Detroit docks for the return trip. Innocent passengers were appalled, as concession stands were robbed and life jackets and deck chairs were thrown overboard. (Courtesy of John Martin Strauss.)

One of the most familiar faces on the Bob-Lo boats was drummer and band leader Joe Vitale, who serenaded guests with music for decades. Vitale introduced the Bob-Lo boat Moonlight Cruises on the Detroit River. He is shown (on the far right) in this 1960 photograph sharing a microphone with an unidentified couple. Capt. Linwood "Red" Beattie is next to Vitale, with another officer on the far left. (Courtesy of Detroit Historical Society.)

Two years after buying Bob-Lo, IBC was hemorrhaging money and was forced to auction off its 84-year-old carved wooden Mangels-Illions Carousel. The whole carousel was replaced by fiberglass replicas. Auctioneer David Norton realized $824,550, with each horse selling for around $23,000. The sale brought an outcry from Bob-Lo fans, and park attendance continued plummeting from a high of over 800,000 in the mid-1970s to 270,000 in the early 1990s. (Courtesy of Detroit Historical Society.)

IBC declared bankruptcy in 1991. The Bob-Lo boats were sold off. Their last sailing was on Labor Day 1991. In February 1992, the park was put up for sale for $9 million, less than half of its 1988 purchase price. Norton Auctioneers of Coldwater, Michigan, was brought in to sell the property at auction on February 10, 1993. Roger Fachini had the winning $3.8-million bid, but Bob-Lo's creditors rejected it after the deposit check bounced, and they took $600,000 less from Enchanted Parks of Seattle. (Courtesy of Detroit Historical Society.)

The 1993 season proved rocky with disputes between island residents and the Canadian Coast Guard. Brash co-owner Michael Moodenbaugh cleaned up the park. Attendance soared on weekends, and the Fourth of July set a single-day record. Moodenbaugh's future expansion plans were put on hold when he had an auto accident that left him in a coma and paralyzed in September. His financial partner Larry Benaroya and his Northern Capital took control of the property, and the ownership group put it back on the market in January 1994. Moodenbaugh is pictured getting soaked on the Log Flume ride before his accident. (Courtesy of *Detroit Free Press*/Zuma Press.)

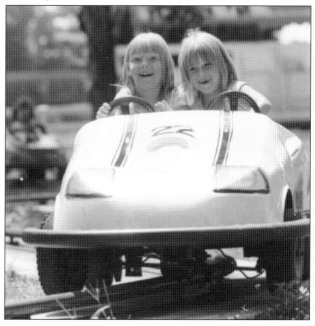

Bob-Lo Island closed for good in September 1993 after almost 100 years of hosting schools, church groups, and families on the 272-acre picnic and party place. Luxury homes have been built, and little is left save the old rusty dance hall of the amusement park. The rides, Moonlight Cruises, Girls Night Out Cruises, the boat bands playing on the Detroit River, Captain Bob-Lo, and a variety of games, shows, and attractions made Bob-Lo a cherished memory for every kid at heart. (Courtesy of Virtual Motor City Collection, Wayne State University.)

DISCOVER THOUSANDS OF LOCAL HISTORY BOOKS FEATURING MILLIONS OF VINTAGE IMAGES

Arcadia Publishing, the leading local history publisher in the United States, is committed to making history accessible and meaningful through publishing books that celebrate and preserve the heritage of America's people and places.

Find more books like this at
www.arcadiapublishing.com

Search for your hometown history, your old stomping grounds, and even your favorite sports team.

Consistent with our mission to preserve history on a local level, this book was printed in South Carolina on American-made paper and manufactured entirely in the United States. Products carrying the accredited Forest Stewardship Council (FSC) label are printed on 100 percent FSC-certified paper.

MADE IN THE USA